K G Rookii XMAS 2010

STEAM
AROUND SCARBOROUGH

CW01184188

STEAM
AROUND SCARBOROUGH

MIKE HITCHES

AMBERLEY

To Bernard and Magdalen

First published 2009

Amberley Publishing
Cirencester Road, Chalford,
Stroud, Gloucestershire, GL6 8PE

www.amberleybooks.com

Copyright © Mike Hitches, 2009

The right of Mike Hitches to be identified as the Author
of this work has been asserted in accordance with the
Copyrights, Designs and Patents Act 1988.

All rights reserved. No part of this book may be reprinted
or reproduced or utilised in any form or by any electronic,
mechanical or other means, now known or hereafter invented,
including photocopying and recording, or in any information
storage or retrieval system, without the permission in writing
from the Publishers.

British Library Cataloguing in Publication Data.
A catalogue record for this book is available from the British Library.

ISBN 978 1 84868 503 1

Typesetting and Origination by Amberley Publishing.
Printed in Great Britain.

CONTENTS

	Introduction	7
One	Scarborough	15
Two	Rails to Whitby	40
Three	Rural Branches	90
Four	The Seamer–Bridlington Branch	112
Five	The Filey Camp Branch	135
Six	Renaissance	151
	Railways Around Scarborough	189
	Acknowledgements	190

INTRODUCTION

The railways around Scarborough were created as part of the York and North Midland Railway, a company which had been promoted in October 1835 to connect York with the London to Leeds line at Altofts junction, a little north of Normanton. Chairman of the Y&NMR was none other than George Hudson, the famed 'Railway King'. Like Captain Mark Huish, General Manager of the mighty London and North Western Railway, Hudson was something of a Machiavellian character and would resort to some underhand tactics in order to win business for his railway interests, not uncommon in these early rough-and-tumble railway mania days.

Indeed, following the opening of the first railway into York, on 29 May 1839 (the Y&NMR line which joined the Leeds and Selby Railway for access to London) Hudson leased the Leeds and Selby Railway in 1840 and promptly closed most of it to passengers forcing them to make the longer journey via his Y&NMR. This was done out of spite because George Stephenson, who had been involved in the establishment of the first railway in the area, the Whitby–Pickering line (opened in 1836), would not make York the centre of north-eastern railway operation as Hudson had wanted. Having established the Y&NMR as the only route which connected York, the Humber, and West Riding, Hudson struck north and promoted routes which would extend the Great North of England Railway from Darlington to Newcastle. As he could make no agreement with the first public railway in England, the Stockton and Darlington, which lay at right angles to his route, he just drove straight through it. For 18 months, the S&D advertised its own through service from Darlington to Newcastle, but any passenger who attempted to use this route found themselves forcibly removed from the S&D train at Bishop Auckland and made to take a horse bus to the next railhead at Rainton Meadows of the line promoted by Hudson.

George Hudson was born in York in 1800 and began his working life as owner of a draper's shop in the city. He later inherited £30,000 which gave him the opportunity to invest in railways at a time when there was money to be made and activity was great. However, in later life, he maintained that this legacy became his downfall. Thus armed, he was welcomed into railway company boardrooms, particularly as he gained a reputation for reviving the affairs of some sickly companies. As Hudson's reputation improved, he soon gained chairmanships. By 1837, he had become Lord

Mayor of York, a title he held when he hosted a banquet in the city to celebrate the opening of the Y&NMR in 1839. He became Member of Parliament for Sunderland in 1845 and gained the unofficial title 'The Railway King' following a meeting with the Prince Consort at which one Frederick Williams made the comment that 'They looked like rival monarchs.' Hudson himself, in later years, stated that it was:

> Sydney Smith, sir, the Reverend Sydney Smith, the great wit, first called me the Railway King; and I remember well that he made a very pretty speech about it, saying that while some monarchs had won their title to fame by bloodshed and by the misery they inflicted on their fellow creatures, I had come to my throne by my own peaceful exertions, and by a course of probity and enterprise.

Following his efforts in the north-east of England and in Scotland, with promotion of a line from Berwick-on-Tweed to Edinburgh, Hudson increased his empire south-westward, and took control of the North Midland Railway in 1842, cutting staff wages in the process. When drivers complained, they were sacked on Christmas Eve and replaced by totally unsuitable characters, including two unemployed drivers who had previously been dismissed for drunkenness. By 1844, he brought about the formation of the Midland Railway, which meant that he now oversaw railways which ran from Bristol in the south-west, Rugby in the south, to Edinburgh in the north.

Only a few years later, however, Hudson's star was beginning to fade. By 1846, the Great Northern Railway had obtained an Act of Parliament for a direct route between York and London, terminating at Maiden Lane on 8 August 1850, Kings Cross coming into use in October 1852. Hudson had objected, although the existing route relied on Huish's LNWR at Euston for access to the capital, he owned most of it. The GNR actually reached York via the Y&NMR, which may appear surprising given Hudson's opposition, but railway share prices were falling and questions were being asked about financial management of his companies. By March 1849, Hudson was being roundly jeered at a meeting of the Eastern Counties Railway when it emerged that share prices were being kept artificially high by paying dividends out of capital rather than profits. Once this information had come to light, confidence in 'The Railway King' collapsed and he faded into railway history having over-reached himself. However, his contribution to the railway network was considerable.

Establishment of the Y&NMR allowed development of railways in the area around Scarborough, having promoted a line from York to the seaside resort in 1845, with a branch to Pickering, thence to Whitby. At the same time, there were routes approaching Bridlington from both Hull and Scarborough. The Hull and Selby Railway promoted the Hull–Bridlington, route, while the Y&NMR promoted a line from Seamer (where it left the York–Scarborough route) to Bridlington, thereby opening up places like Filey and Flamborough to tourism.

Scarborough had been a holiday resort since 1667, having been a spa town since 1620, following discovery of a spring in the locality. Indeed, the town advertises itself

as the oldest seaside resort in Great Britain. It is not surprising, therefore, that the town would become the main centre for railway traffic as the network in the area developed. At the same time Victorian society became interested in sea-bathing as a healthy pursuit, not to gain a tan, as this was considered 'common' and only the 'working classes' became 'brown' during the summer, but to take advantage of the fresh sea air and sunshine. As the 'Filey Guide' of 1856 makes clear:

> ... the bay is spacious and open, the air bracing, being free from thick and fetid vapours, inspiriting and genial; all combining to render Filey a highly fashionable resort, and much frequented watering place.

It was the coming of the railway which opened up places like Filey and Whitby to Victorian holidaymakers, Filey being nothing more than a fishing village before the railway arrived. Indeed, the population of Filey was only 505 in 1801, only rising to 579 a decade later. By 1851, the population had increased to 1,885, many coming into the town to cater for these new holidaymakers. In those days, only the wealthy could afford seaside holidays and they would often stay for the whole of the summer months, many having had summer homes built in the resort towns, an example being 'The Crescent' in Filey. Thus, they would bring their families, servants, luggage, and carriages by rail to the seaside.

Seaside holidays only became possible for the 'working classes' as the nineteenth century came to a close. With the 1898 Tramways Act came the opportunity for cheap travel and the railways responded by offering cheap excursion tickets to many destinations, including seaside resorts, on a daily or weekly basis. For example, passenger journeys starting at Filey totalled 38,646 in 1881 increasing to 47,405 in 1894, reaching a peak of 77,334 in 1919 (following the end of the First World War). These increases in traffic were reflected in seaside resorts throughout the country.

By this time, the railway network around Scarborough had become part of the North Eastern Railway, having been formed on 31 July 1854 following merger of the Y&NMR with the York, Newcastle and Berwick Railway, a George Hudson ally, and former rival which Hudson had tried to suppress, the Leeds Northern Railway. Not long after the NER had been formed, a line from Scarborough to Whitby was in hand, and an Act for such route received Royal Assent on 5 July 1865 and after several false starts was finally opened in 1885. With the opening of the Scarborough–Whitby line the railway network was virtually complete. The only other new line to open in the area was a short branch off the Seamer–Bridlington line between Filey and Hunmanby to serve a new holiday camp. Approval for the line was given in July 1945 and the new line and station (known as 'Filey Holiday Camp') was opened in May 1947.

In 1923, the NER became part of the new London and North Eastern Railway, following the 'Grouping' of 120 railway companies into four groups (the Great Western, Southern, London Midland and Scottish Railways being the three other new companies). This 'Grouping' came about due to wear and tear on the railway

network during the First World War, when the railway network came under State control, being seen as of national and strategic importance. Although the war had ended in 1918, the government did not relinquish control of the railways until 15 August 1921. While wartime traffic had increased maintenance costs of the railway network, the government were very slow in compensating the companies, sums paid out were often lower than those claimed. The North British Railway (which served the Royal Navy at Scapa Flow) had claimed £10,681,243 but only received £9,790,545 despite expensive legal costs in pursuing their claim. Eventually, the State allocated £60 million to be shared between the railway companies.

During and since the war, there had been calls for nationalisation of the railways. While there was some sense in central control of the system, which would allow rationalisation and standardisation, there was political opposition to nationalisation of the railways in peacetime (that would have to wait for another quarter of a century) and wholesale amalgamations were envisaged. Sir Eric Geddes, ex Deputy General Manager of the NER was asked by the government to prepare a scheme, embodied in the 1921 Railways Act, to reorganise the railway companies into four groups. By this legislation the LNER was formed by the merger of seven companies; the Great Northern, Great Eastern, Great Central, Hull and Barnsley, North British, Great North of Scotland, and, of course, the NER. Prior to the 'Grouping', the NER had merged with the Hull and Barnsley on 1 January 1922.

Following the grouping, the LNER, like the other railway companies, were hit by road competition as soldiers, who had learned to drive while in the forces, were demobbed and became lorry, coach, or bus drivers, many becoming owner/drivers of lorries and coaches in competition with the railways. The lorry had the advantage of being able to collect and deliver from door to door without transfer of goods and its attendant risk of damage. Coaches could also take passengers direct to destinations, many railway stations being some way from the towns which they served. The railways competed with coaches by offering cheap excursion tickets and running extra trains during the summer months, often at a loss. Advent of the 'Holidays with Pay Act' 1938, allowed many working class people to have holidays for the first time, which benefited the railways as well as the roads. The full benefit of holidays with pay, however, would not really emerge for another decade.

The railway network around Scarborough saw an increasing number of excursion trains during the 1930s, many of these trains being made up of non-corridor stock, which could be uncomfortable for passengers of such trains, headed by loco's not normally used for passenger services. Such was the importance of holiday traffic to the LNER, that, from the summer of 1938, there was a departure at 10.30 am every weekday from Scarborough Central to Kings Cross, via Filey, Bridlington, and Driffield as well as the usual Scarborough–Kings Cross, via York, services.

Along with road competition, the railways were also affected by the Great Depression of the 1930s. Following the events of the First World War, Britain had lost its industrial pre-eminence and staple industries, such as coal, steel, shipbuilding, and textiles began to shed labour as foreign competition began to bite into British

export markets. The brunt of this industrial decline fell on the north, Wales, Scotland, and Northern Ireland. The northeast was famous for its coal mines and shipbuilding, while the West Riding of Yorkshire had its woollen textile industries as well as coal mines.

The woollen industry, in particular, was never known for high levels of unemployment until the 1930s. In this period, unemployment rates in the West Riding were running at between 10% and 25%. The coal industry had an unemployment rate of 41.2% in 1932, while iron and steel had a rate of 48.5%, and shipbuilding had a rate of 59.5%. It was from these areas that the resorts around Scarborough drew many of its visitors. Consequently, demand for railway freight and passenger traffic on the LNER declined sharply, rates and fares having to be cut to attract business, much passenger business coming from the more prosperous south and midlands, bringing new holidaymakers to replace those lost in the north as the 'slump' began to bite. Indeed, passenger numbers increased substantially during the 1930s. In 1933, Scarborough attracted 685,647 passengers, increasing to 739,654 in 1934. Even in the depths of the Great Depression, Scarborough station had over 550,000 passengers pass through in 1932. Unemployment rates did not improve significantly until around 1936, down to 25% in the coal industry, 29.5% in iron and steel, and 30.6% in shipbuilding. Rates fell further in 1938 (22% in coal, 24.8% in iron and steel, and 21.4% in shipbuilding) as Britain prepared for war, even though Neville Chamberlain had promised 'Peace in our time' following negotiations with Adolf Hitler over the Sudetenland in the same year.

The inevitable happened when Britain declared war on Germany on 3 September 1939, following Hitler's invasion of Poland. Before war was declared, the national railway system had come under State control again from 1 September. In those first few days, children were evacuated by rail from likely air raid target towns and cities and moved to safer areas. Children from Hull, Hartlepool, Sheffield, and Rotherham were evacuated to places like Filey, Whitby, and Scarborough by train, some stayed for only a short time, while others remained for the duration of the war and longer. Military interests were also served by rail at this time as sea defences were set up along the coast.

Following outbreak of war, emergency passenger timetables were introduced which drastically reduced services and a maximum 60 mph speed limit was applied to the whole of the system to reduce maintenance requirements. However, with no immediate threat of invasion, restrictions were relaxed and maximum speeds increased to 75 mph by December 1939. In 1940, the railways were even timetabling extra trains for the Whitsun weekend, just as Germany invaded the Low Countries and the threat of invasion reared its head again. Thus, these extra trains never materialised as the Dunkirk evacuation meant that the railway network was required to transport soldiers, survivors, and evacuees from Dover and the Channel ports. The blitz then followed and the railways came under increasing strain as freight demand increased at a time when men were required for the army, women taking many of male railway roles. The burden increased as the war went on, and maintenance of

the system fell into decline. The blitz also took its toll on the railways with bomb damage to the network and its stations, all of which meant that the railway system was in a parlous state by the time hostilities had ceased.

When peace finally returned, the LMS had calculated that it would cost £14 million (at 1945 prices) to catch up with arrears of maintenance, and a further £26 million to bring its track back up to pre-war standards. The LNER bill may well have come to a similar amount. The railways had suffered through the depression and did not really have the resources to keep going. The LNER had not paid a dividend to its share holders since 1934. It could be argued that the LNER was virtually bankrupt. Despite the state of the railway network, the government did not compensate the companies anywhere near what it would cost to bring it back to anything like its pre-war condition as it was seen as a low priority for scarce resources when blitzed towns and cities needed rebuilding. The railways were, therefore, forced to make do with what they had.

Election by a landslide of a Labour government in 1945, with its commitment to nationalisation of key industries, meant that the issue, first mooted after the First World War, of the railways coming under State control raised its head again. During the war a committee had been set up to investigate railway nationalisation. They concluded that the railways should remain as the four private enterprises when hostilities ceased. The new government did not accept this and the railways became State owned from 1 January 1948. The LNER relinquished its Scottish lines, along with the LMS, to form a new Scottish Region. In England, the old LNER was split into the Eastern Region and North-Eastern Region of British Railways (the railway system around Scarborough became part of the North-Eastern Region). In 1967, however, the ER and NER became just the Eastern Region with its headquarters at York.

The post-war period brought an economic 'boom' as reconstruction was underway. This brought a period of full employment which was to last into the 1970s and would have consequences for the railway network. These were the real 'golden years' for the steam railway as the benefits of holidays with pay became a reality. The effects of the private car were not felt until the 1960s and long distance travel to the seaside from the industrial towns was usually by rail, although the motor coach was making inroads into rail traffic by the late 1950s. Thus, the 1950s saw a peak in holiday and excursion trains as people sought a week's holiday at places such as Scarborough, Whitby, and Filey (including Butlin's Filey Holiday Camp opened in 1945).

The new British Railways committed itself to steam traction, rather than investigate diesel and electric motive power as the USA and Europe had done, which pleased railway enthusiasts but did little to attract labour in what was a heavy and dirty industry at a time when newer, cleaner, industries, who paid higher wages, required labour. Thus, the 1955 'Modernisation Plan' was introduced to replace steam with diesel and electric traction. This would take at least another decade to realise. Meanwhile, the cost of renewal of motive power, rolling stock, and infrastructure were spiralling out of control. In order to attempt to reduce costs and bring railway finances back under control, the Conservative government

of early 1960 tried a new managerial approach and a new British Railways Board was created with one Dr. Richard Beeching as Chairman. In the Spring of 1963, Beeching introduced his Infamous 'Reshaping Report of British Railways' which advocated wholesale closures of over 5,000 route miles and 2,350 stations. In the Scarborough area stations had already been closed at Cayton (1952), Gristhorpe (1959), and Lockington (1960). The line between Seamer and Pickering had gone by 1950, and the line to Kirkbymoorside in 1953. The 'Reshaping Report' advocated that all routes to Whitby should close and, despite local protests, the coast line from Scarborough to Whitby was closed on 5 March 1965, along with that from Pickering to Whitby. Only the line from Middlesbrough to Whitby was retained.

In 1968, plans were announced to close the line between Seamer and Hull, via Filey and Bridlington. A public enquiry showed 3,444 objections, including 14 local authorities. Objectors stated that 2,892 were regular users of daily services, and summer holiday trains carried 88,000 passengers, excursion trains carried a further 108,000, a total of 2,300,000 passenger journeys a year covering 44,000,000 miles. On 29 July 1969, Richard Marsh, Minister of Transport, refused consent to full closure, but agreed to closure of Lowthorpe, Burton Agnes, Carnaby, Flamborough, and Speeton stations. Thus only the lines between York and Scarborough, Seamer and Bridlington to Hull, and Middlesbrough to Whitby remain open to traffic, now mainly operated by two or three coach 'Sprinter' DMU sets. In the summer months, however, the York–Scarborough line has a regular steam operated train service and the preserved Pickering–Grosmont line has regular steam services operated by the North Yorkshire Moors Railway.

In writing this book, I hope that I have recalled the glory days of the steam railway around Scarborough when people took their seaside holidays in the local resorts and took steam excursions to other attractions in the area, recalling carefree times when summers were always sunny, the beaches golden, and everyone was safe to enjoy themselves for one or two weeks a year.

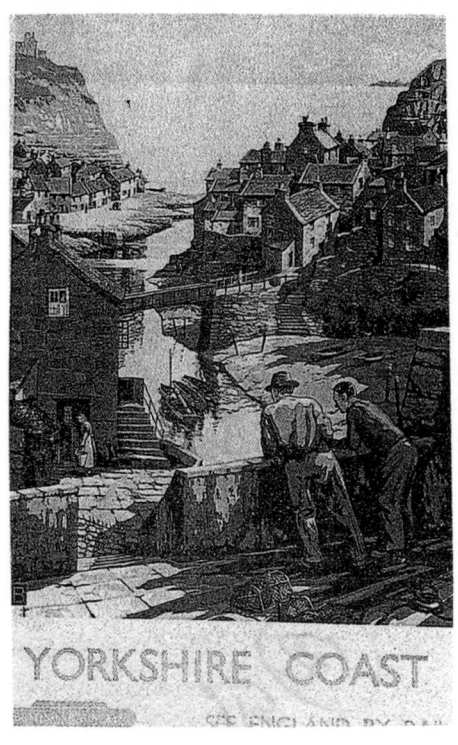

A BR poster showing Staithes, just north of Whitby, promoting the Yorkshire coast. Even by the 1950s, the railways could still rely on significant revenue from tourist traffic to the seaside resorts of Britain before the rapid expansion of road traffic and private car ownership spelt decline in tourist railway traffic. (Author's collection)

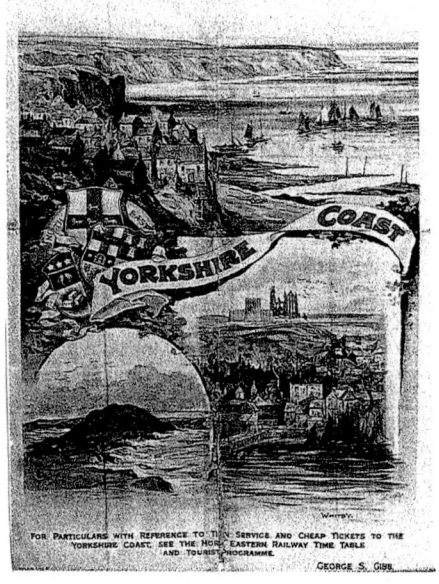

A poster by the North Eastern Railway of 1900 showing the beauties of the Yorkshire coast. It was these advertisements that brought tourism to the area, most using the railway to their destinations along the coast, bringing much revenue to the NER. (Author's collection)

ONE

SCARBOROUGH

Having been established as a resort since the seventeenth century, it was inevitable that Scarborough would attract interest from fledgling railway companies who envisaged that a line to the town could become profitable. Initially, a project for a railway from York to Malton and Scarborough had been suggested as early as 1833 but nothing occurred until 1840, when a survey was carried out under the direction of Sir John Rennie for a railway from Scarborough harbour to a junction with the Y&NMR near York. A plan for this route was deposited on 1 March 1841. However, a year later another plan was deposited for a new scheme, a line from York to Malton and Scarborough, with a branch to join the Whitby and Pickering Railway at Pickering. On 30 November 1843, further plans were deposited for the railway to commence via a junction with the Y&NMR and Great North of England Railway, near York. This scheme had the backing of George Hudson, who appointed Robert Stephenson as Engineer. Hudson, himself, felt that Scarborough could become, in his words 'The Brighton of the North' once the railway arrived. One objector, George Knowles, who said that the town was 'Queen of watering places' (a phrase used in railway advertising for the next 80 years) felt that a railway to the town would damage its reputation. Whatever the feelings of objectors, construction of the railway would allow Scarborough to become the premier east coast resort.

Construction of the new railway took around a year to complete, although some preliminary work had been undertaken prior to obtaining the Act of Parliament in 1844. The only major works required over the 42 mile route were 25 bridges, the two largest being the bridge over the River Ouse at York and the five arch Washbeck Viaduct at Scarborough.

Official opening took place on Monday 7 July 1845, when an inaugural train of 35 coaches, double-headed by locos *Hudson* and *Lion*, brought a large party to Scarborough at around 1.35 pm, having taken some three hours from York, the train having made stops at Castle Howard, Malton, and Ganton. After the festivities, the train departed from Scarborough at 3.45 pm.

At opening, the main station buildings at Scarborough were virtually complete, although the overall roof was not yet in place at the passenger station, and the goods shed in the station yard had not yet been built. However, not long after opening, the station had two platforms, connected at the north end, with four tracks between

them. Each track had a pair of turntables, one at each and of the platforms, with a connecting track between them so that locos and rolling stock could be released from platform tracks on to the inner lines.

Buildings consisted of a large central booking office, to the left of which was the Superintendent's Room, second class waiting room, toilets, Porter's room, and store room. To the right of the booking office was the first class waiting room, Ladies Waiting room, and refreshment rooms, which stood at right angles to the main building. Above the refreshment rooms there was accommodation, which had been the Stationmaster's house, becoming the station's hotel with ten bedrooms. The station was designed by Y&NMR architect George Andrews, who went on to design other station buildings in the area. The clock above the station was a later addition, having been supplied by Potts of Leeds for £110. It was, originally, gas lit which, along with clock maintenance, was paid for by Scarborough Council. Since opening, the station has undergone many modifications and additions over the years as rail traffic increased to cater for ever increasing holiday trade.

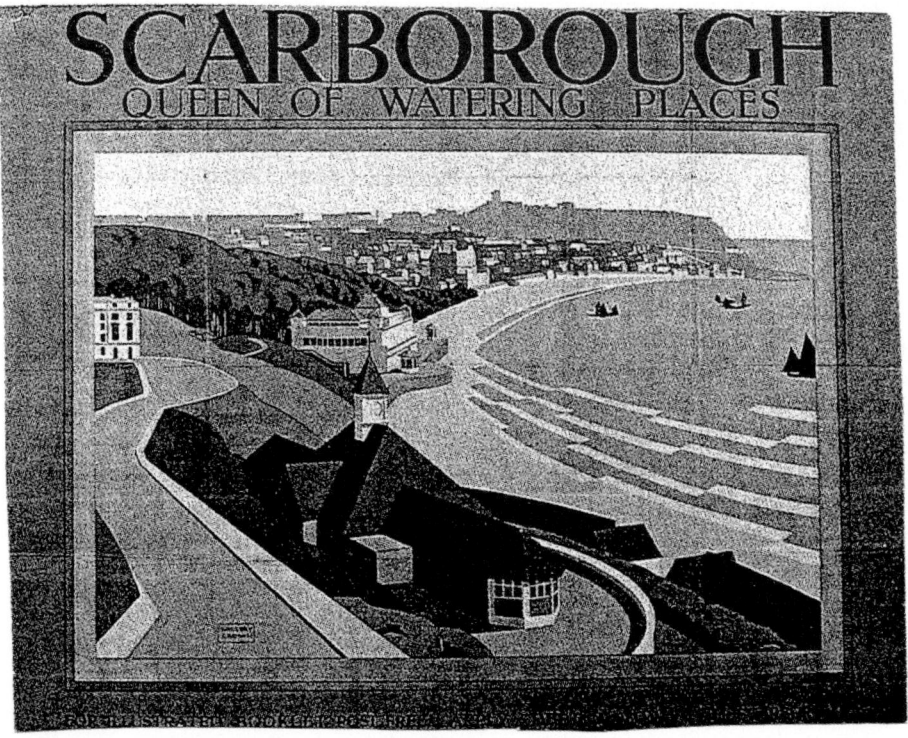

A NER poster showing Scarborough and using the slogan 'Queen of Watering Places' which had been coined to advertise the benefits of the seaside town long before the railway arrived. The railway companies would go on to use this slogan for many years to come. (Author's collection)

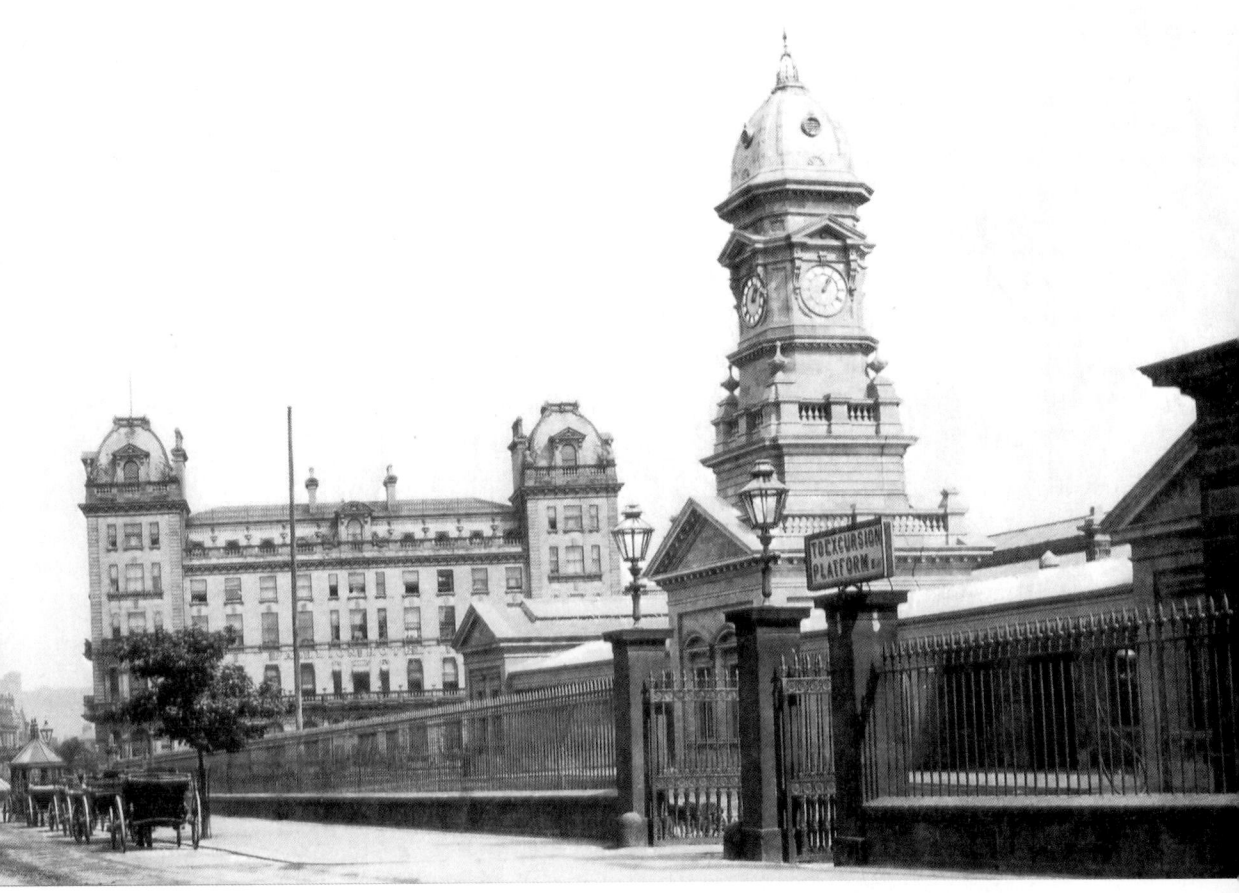

The entrance to Scarborough Station as it appeared in the late nineteenth century with carriages awaiting trains. The station entrance in Falsgrave Road leads to the town centre, which is just visible beyond. The clock, built by Potts of Leeds is a prominent feature and is still a landmark. Scarborough Station provided only £65 worth of revenue when the North Eastern Railway was formed in 1854, but would rise to an average of around £3,000 per week at the 'Grouping' of 1923. (Author's collection)

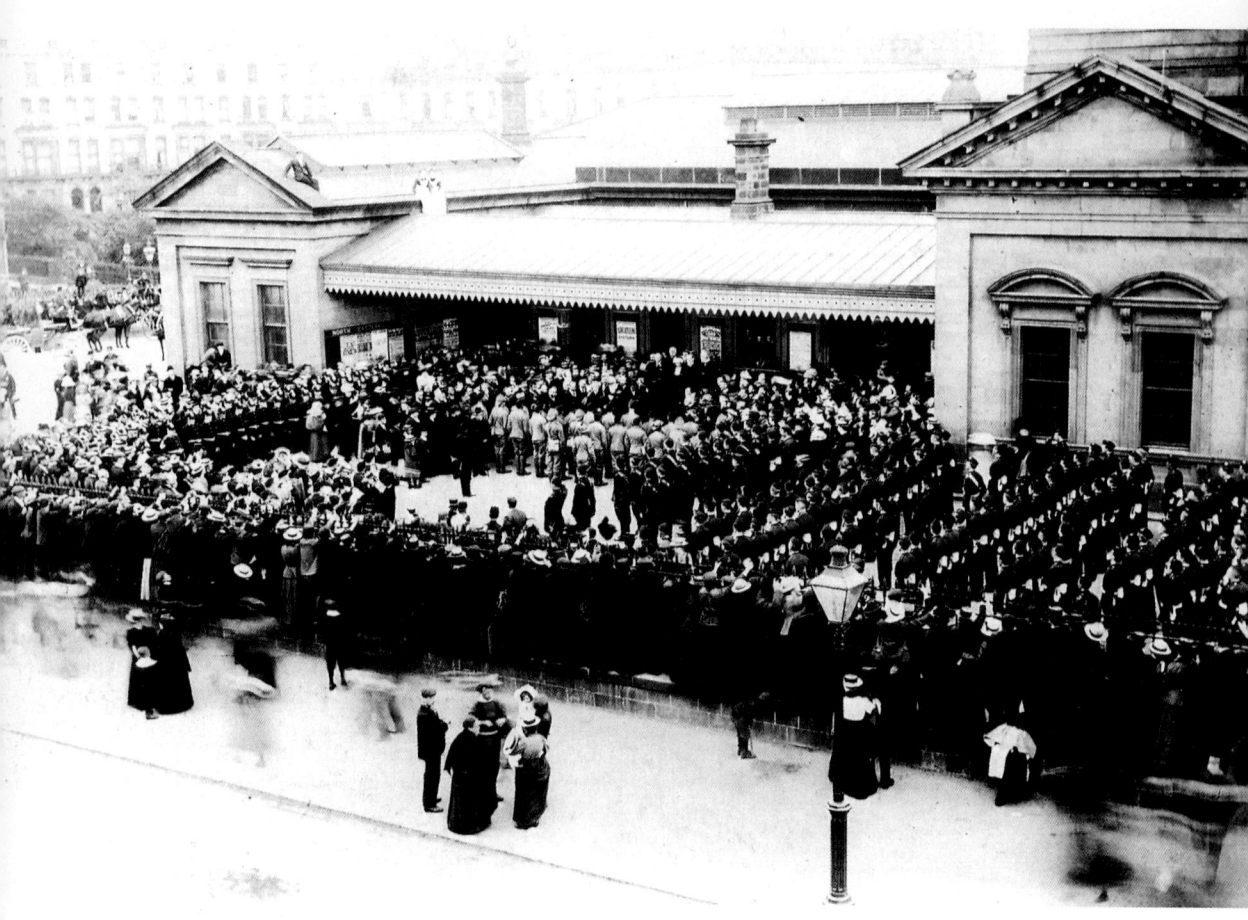

A scene outside Scarborough Station, which appears to show soldiers on parade and being blessed by religious leaders. From the uniforms it would appear that troops were either going off to southern Africa to fight in the Boer War or were being greeted after returning home. It must have been quite an event as there are many spectators, no doubt most were relatives of the soldiers involved. (Author's collection)

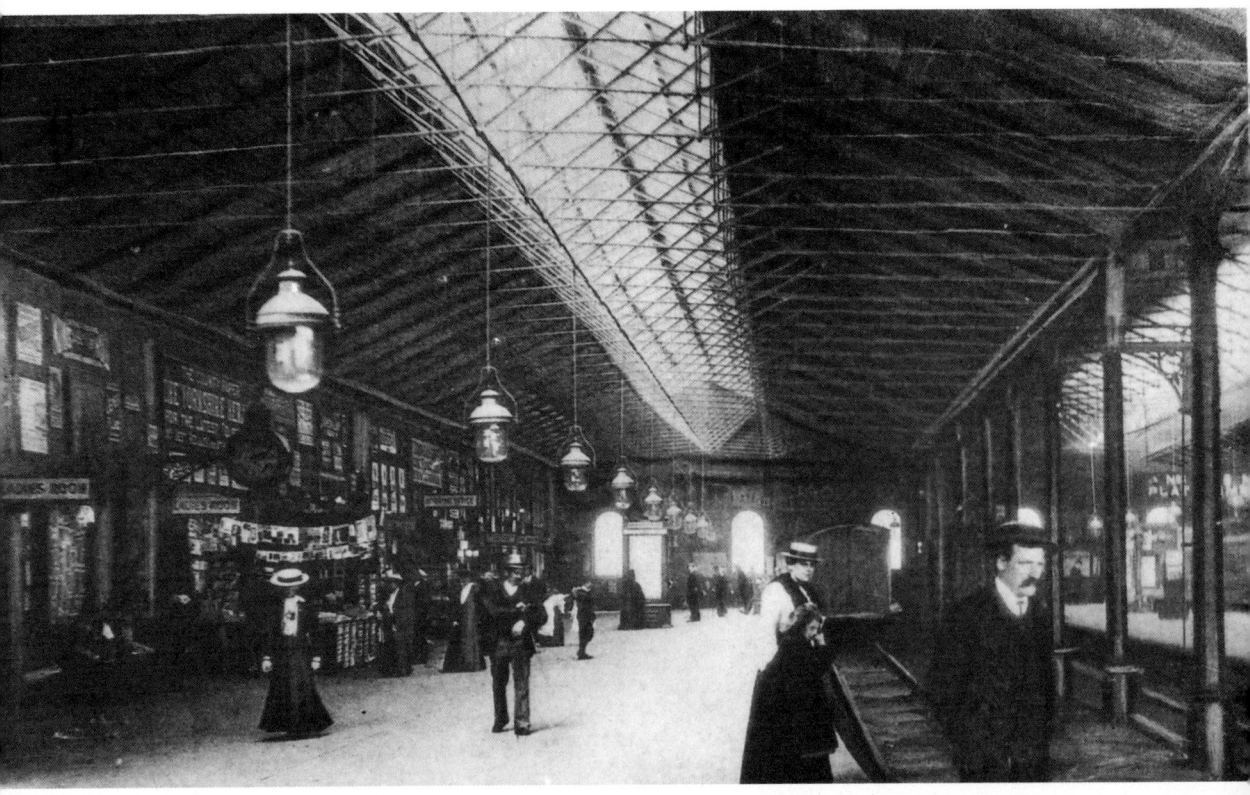

Interior of Scarborough Station during the Edwardian period showing the ornate gas lighting above the platforms and kiosks behind. The station was kept busy with receipts growing thus:

Years	Passengers	Receipts	Parcels, etc*	Total
1885	222,042	£37,525	£5,947	£43,472
1890	248,221	£41,586	£6,671	£47,257
1895	279,575	£44,574	£6,739	£51,313
1900	313,271	£48,102	£10,339	£58,441
1905	328,304	£47,952	£9,979	£57,931

*Parcels also includes horses, carriages and dogs.

Revenue at the station continued to increase and in 1911 £60,371 was taken, growing to £148,461 in 1921. However, the Great Depression of the early 1930s adversely affected revenue, which fell back to only £74,936 in 1931. Even 1d platform ticket sales, which had contributed £774 19s 7d to station revenue in 1922 had fallen to £471 17s 10d only ten years later as the effects or the failing economy began to bite. (LOSA)

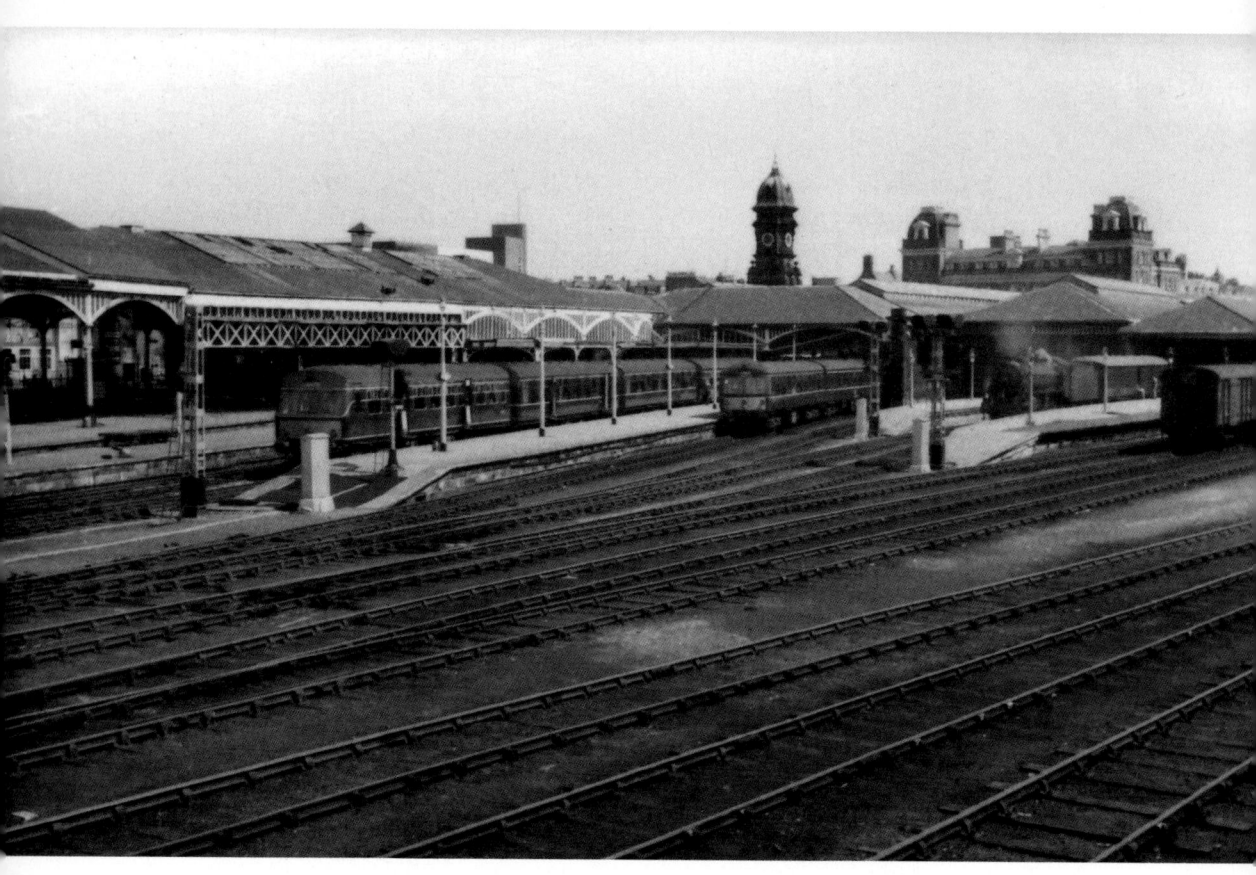

A general view of Scarborough Station, summer 1965. (R. Carpenter)

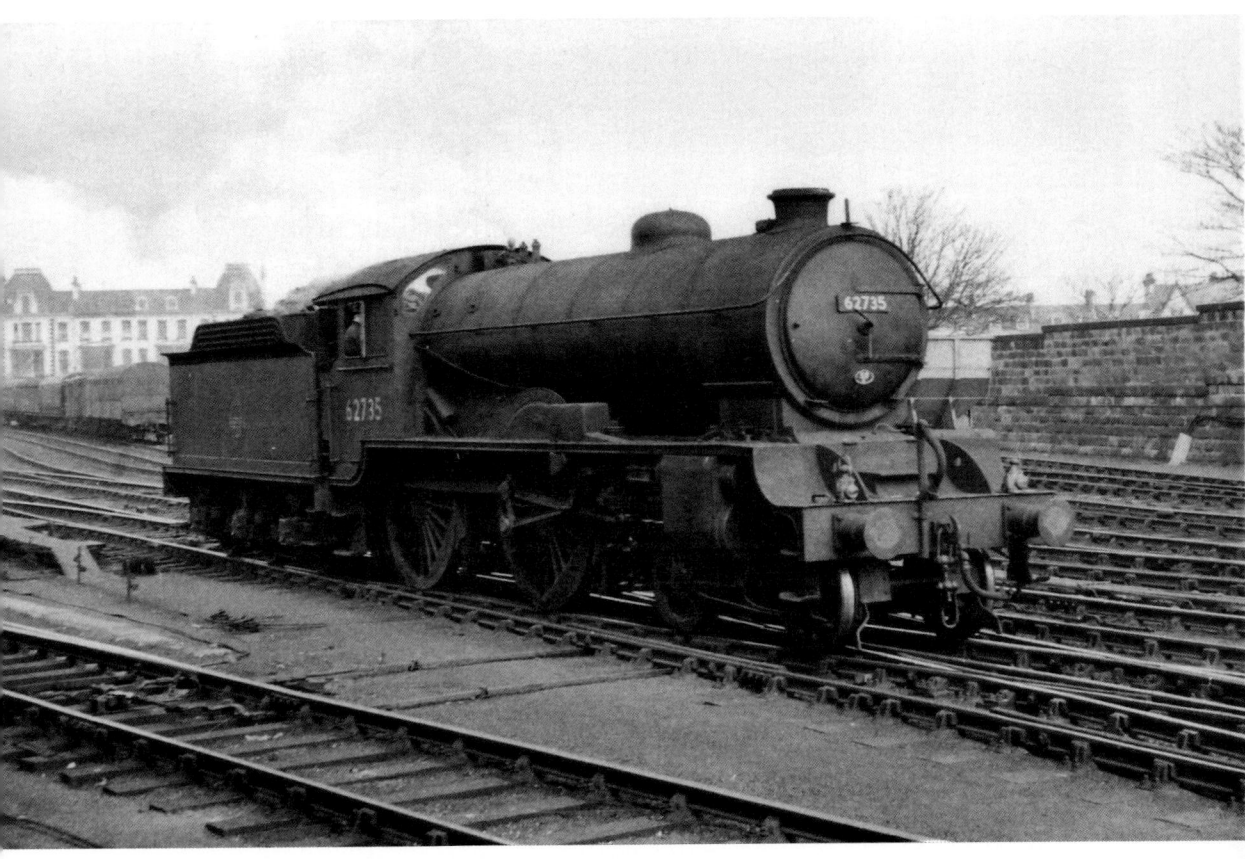

Resting at Scarborough Station on 30 April 1958 is ex-LNER Class D49 4-4-0 No. 62735 *Westmorland*. These engines were a common sight at Scarborough on trains from Hull, York and Leeds, Scarborough shed having an allocation for some years. (R. Carpenter)

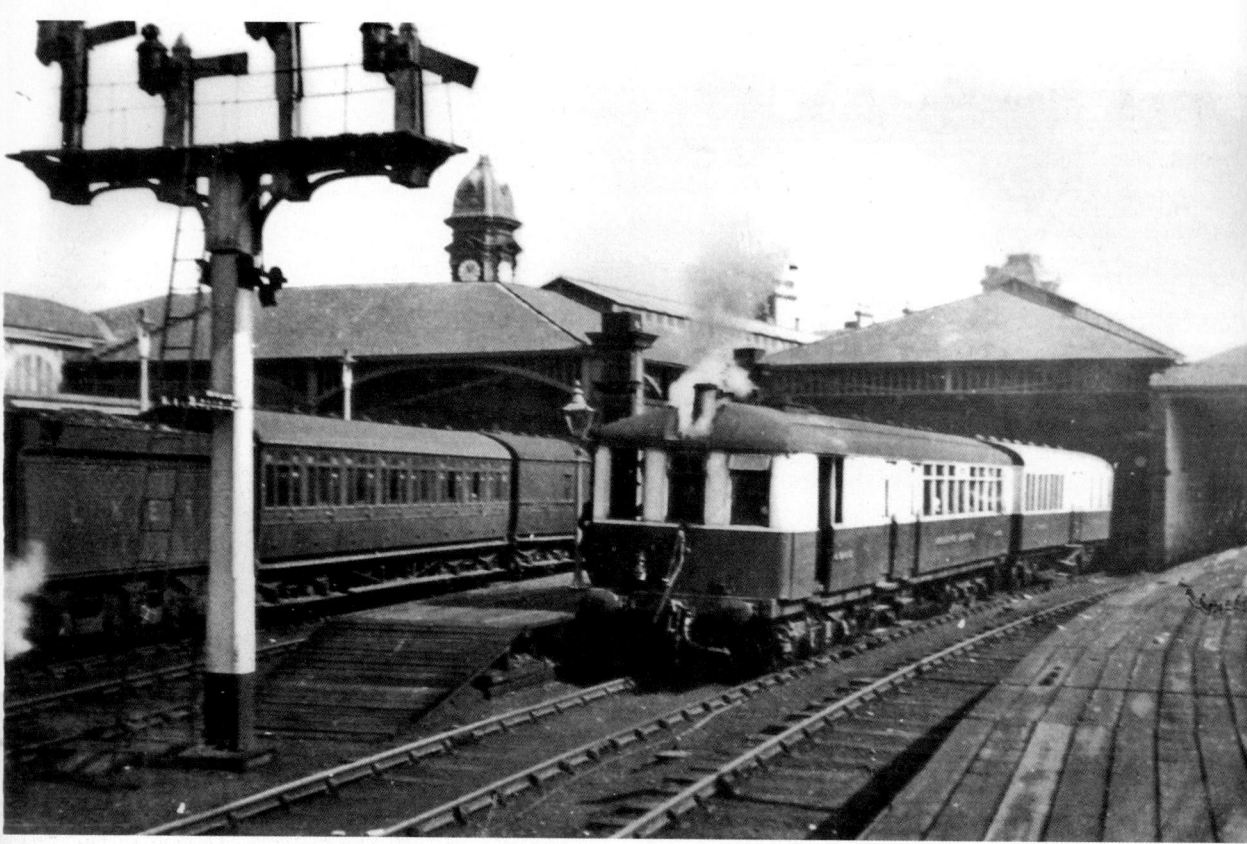

Scarborough Station in the 1930s with an express about to depart, possibly the famous 'Scarborough Flyer', with an LNER D49 4-4-0 at the head. In the foreground are Sentinel railcars, which were popular with the LNER because they were cheaper to operate on minor branch lines than the usual locomotive and rolling stock. First Sentinel railcars were built for trials on the Jersey Railway in 1923, proving to be more economical in service than the Sentinel company had suggested, each railcar saving the railway some £600 a year in coal costs. Only after demonstration at the British Empire Exhibition in 1924 did the LNER show any serious interest, the old NER having converted a Leyland bus in 1922 to run on rails in the York area to compete with ever-growing road transport and reduce running costs. The LNER went on to construct a purpose built 'railbus' in 1923.

As a result of trials on York–Harrogate and Newcastle–Whitby–Scarborough services, the LNER ordered two Sentinel railcars in 1924, entering service in May 1925, operating in East Anglia, at a cost or £3,875 each. Experience gained with these railcars, and one loaned from the LMS, encouraged the LNER to consider ordering two more vehicles in March 1926, one to operate in the north-east of England, the other between Scarborough and Pickering, these entering service on 14 May 1927 (a Clayton railcar coming into use in July after trials over the York–Whitby–Scarborough–York circular). However, the railcar intended for Scarborough went to Hull to operate services to Brough or Beverley.

By 1928, the LNER had ordered 50 more railcars, 40 of which were Sentinels, a six-cylinder car was worked on the York–Whitby and York–Scarborough services, proving impressive on steeply graded sections and reaching speeds of up to [*continued opposite*]

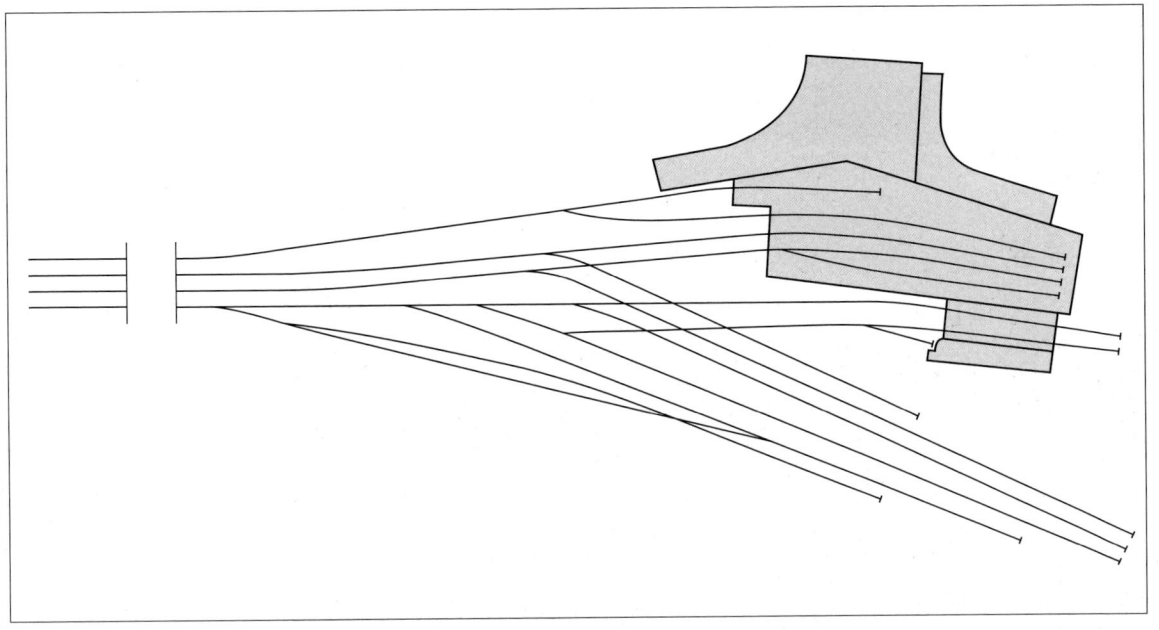

A plan of Scarborough Station as it appeared around 1870. (Author's collection)

55 mph on the level and a further 18 of these cars were delivered between November 1928 and January 1929. These railcars were painted in the familiar cream and green livery, although the earlier cars had been painted in carmine and cream, changing to the new livery when undergoing repairs. In September 1930, twin car units were introduced on the circular York–Pickering–Whitby–Scarborough–York services and ran at express speeds (48 miles in 42 minutes) between Scarborough and York. On the steeply graded section between Robin Hoods Bay and Ravenscar, speeds of between 20 and 26 mph were obtained in this 1 in 39 climb. Between Hawkser and West Cliff, which included a climb of 1 in 39, a speed of 15.6 and 19.1 mph was obtained, with a loaded horse box in tow. At the end of 1932, three Sentinel railcars, no's 246 *Defence*, 247 *Royal Sovereign*, and 248 *Tantivy* were delivered to Scarborough for use on the Scarborough–Whitby–Saltburn services. It is likely that the cars seen here are operating this train. While the economy in service of these Sentinel railcars staved off road competition for a short time, increasing repair bills made them uneconomical over time, and they became rather shabby in appearance as they were in constant use. Thus, their lives were comparatively short, lasting in service from 1925 to 1947, none entering BR service. They were, however, symbolic of LNER local traffic. (LOSA)

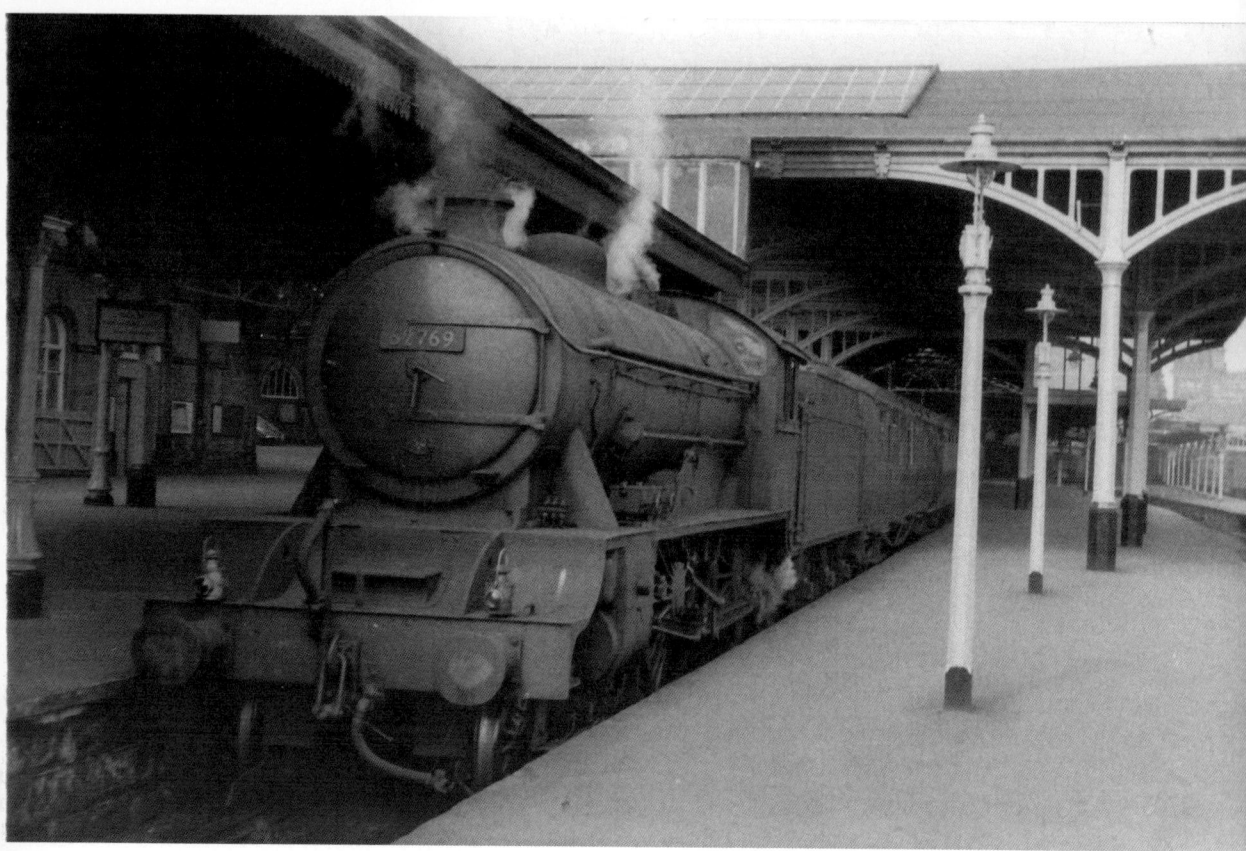

Ex-LNER Class D49 4-4-0 No. 62769 *The Oakley* waits to leave Scarborough Londesborough Road Station with an excursion train on 30 April 1958. In the late 1890s, there was inadequate capacity at Scarborough Station so the NER obtained powers to build a brand new station for excursion traffic. The site chosen was the old engine house yard and the cost for new buildings for the station was £7,500. A new bridge was also built, at a cost of around £5,500, to replace the Washbeck viaduct, with its five arches, to accommodate the extra tracks needed. New carriage sidings were provided at Northstead, some 4 miles of track being laid at a cost of £4,000, and a new signal box at Washbeck cost another £400.

The new station was opened on 8 June 1908 and consisted of one through platform, nearly 300 yds long, and a shorter 250 yds bay platform. Most excursion trains arrived on the through platform, offloaded their passengers and then worked forward through Falsgrave Tunnel and up to the carriage sidings where trains were stored for the day and locos were turned, coaled and watered ready for return workings in the evening.

The circulating and waiting area at Londesborough Road Station was well organised, rows of barriers being set up so that passengers could be separated into groups according to which train they were returning on, enabling staff to ensure that most passengers caught the right train despite the fact that several trains departed within minutes of each other. The excursion station did handle ordinary traffic, especially if there had been a derailment, or there was track relaying at the central station. An early morning train from Middlesbrough stopped here to allow schoolchildren to alight during term time during the 1950s. The station at Londesborough [*continued opposite*]

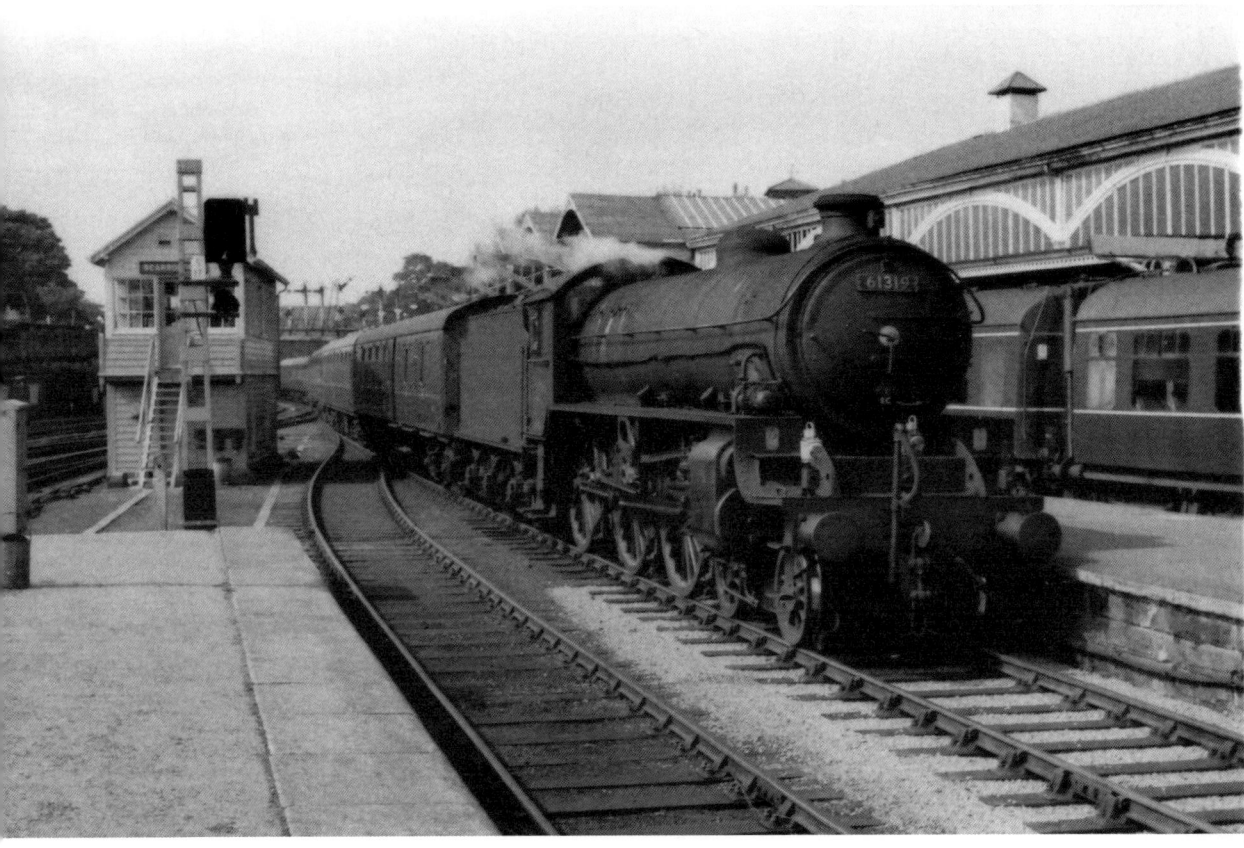

Ex-LNER B1 4-6-0 No. 61319 at Scarborough with an empty stock train. (R. Carpenter)

Road was also used for a variety of purposes over the years: Lloyd-George once gave a speech from the platform; it was used as a parade ground during the First World War; it stored Robinson's coaches in the 1920s; it was used as a wet weather rehearsal area for the Open Air Theatre performers in the 1930s; and became an army supply depot during the Second World War – a versatile station indeed!

As road transport took control during the 1950s and '60s, declining excursion traffic led to closure of the station on 4 July 1966, although the last train had departed on 24 August 1963. (R. Carpenter)

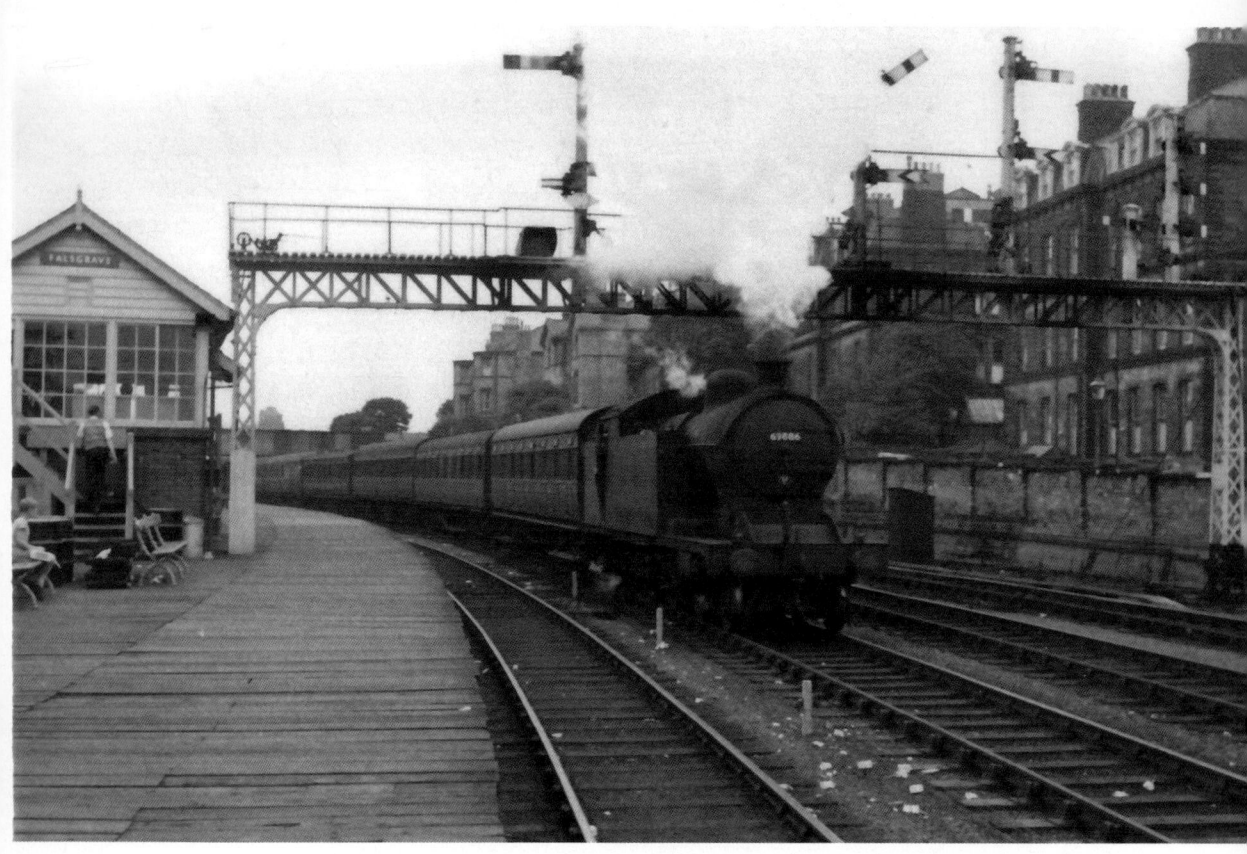

Ex-LNER A8 4–6–2T No. 69866 passes Scarborough Falsgrave signal box with empty stock on 29 July 1955. Out of view, behind the signal box is the mouth of Falsgrave tunnel, start of the old coastline to Whitby and Saltburn. Trains from Whitby entered Scarborough behind the signal box and met the main line just beyond. To enter the central station, these trains would have had to reverse at the junction but after opening the branch trains crossed the main lines to and from York to use platforms on the south side of the station. However, after a chaotic summer season in 1933, a small bay platform was built for these trains at the end of platform one, the following year. After the line was opened, John Waddell, the contractor, wanted to open a goods station at Scarborough, but was blocked by the NER who compulsorily purchased the site at Gallows Close in 1891. By 1894, the NER had opened its own goods shed here with a large entrance in Falsgrave Road. A proper goods shed was started in 1901 and was opened, together with extensive sidings in 1902. A bridge over Woodland Ravine, on the branch, was built in 1904, and was hit by a bomb in 1940, the abutment on the south-east corner dropping on to the tracks below, causing two or three days of traffic delay. Just beyond Woodland Ravine bridge were extensive carriage sidings opened in conjunction with the new Londesborough Road station in 1908. These allowed summer excursion trains to unload and run forward through Falsgrave tunnel. At the north end of the carriage sidings there was a turntable, along with coaling and watering facilities for the incoming locos as they were prepared for their return trips. (R. Carpenter)

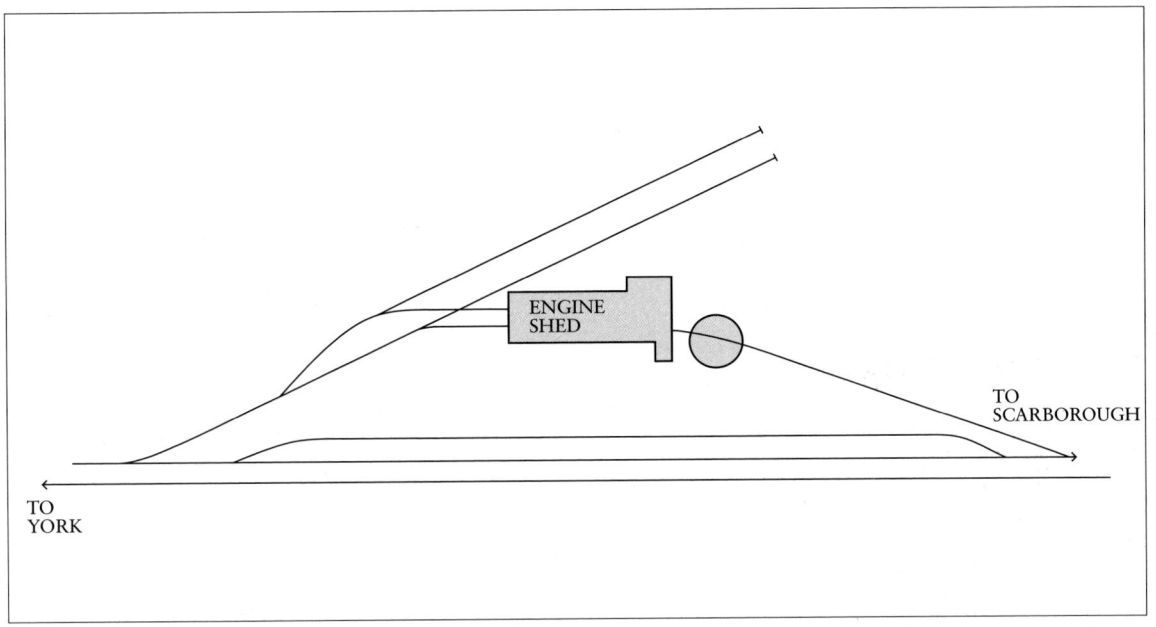

A plan of the loco shed at Scarborough as it appeared in 1865. This was the original of 1845, which was demolished in 1906/7 to make way for Londesborough Road station. This original shed had not been in use since 1882 when a new roundhouse was opened in Seamer Road. First locos to work a train to Scarborough were Y&NMR 0-6-0 *Hudson*, built by Robert Stephenson & Co. in 1845, and 0-4-2 *Lion* built by the same company in 1841. This inaugural train was made up or 35 coaches and ran on 7 July 1845. Early locos allocated to Scarborough were likely to have been NER 2-2-2 and 2-4-0s, later to be replaced by locos displaced from Kings Cross–York–Edinburgh services, such as *Fletcher* 901 and *Tennent* 1463 2-4-0s, Class G 2-4-0s (later rebuilt as 4-4-0s), Class I & J 4-2-2s, and Class F, Q and R 4-4-0s. (Author's collection)

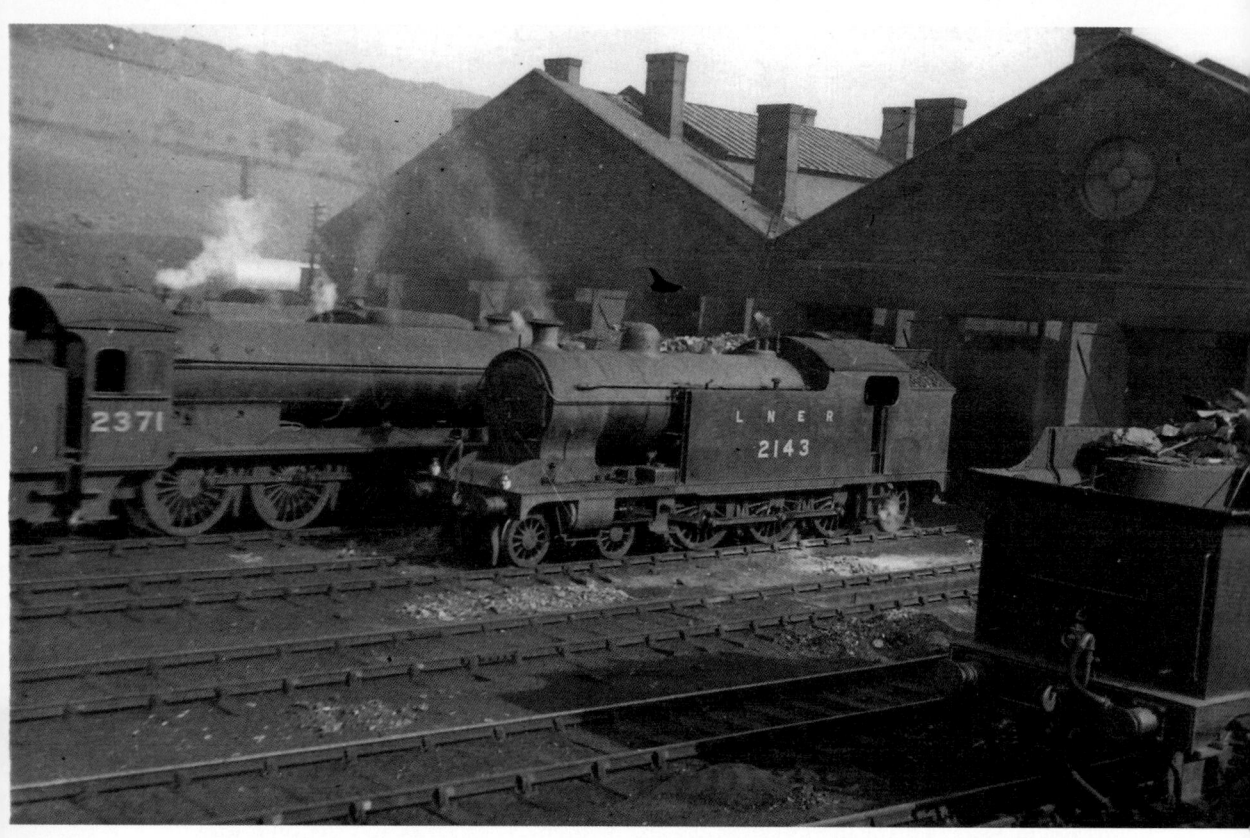

A roundhouse was authorised in 1879, at an estimated cost of £5,393 for the shed, and £2,976 for engineering work. On 11 March 1880, a tender of £4,330 8s 6d was accepted for construction, work being completed in 1882, costs over–running by £187 13s. The turntable added cost of £335. An eight road straight Shed, the one in this view, was opened in 1890 and the roundhouse fell into disuse for locos in traffic, but was used to store engines, especially in winter time when there was a sharp fall in traffic. In LNER days, locos allocated to the shed included D49 4-4-0s 222 *The Berkeley*, 226 *The Bilsdale*, 258 *The Caltistock*, 274 *The Craven*, 279 *The Cotswold*, and 353 'The Derwent', all arriving new from Darlington works in 1934. In May and June 1939, D49 No. 258 left the shed, but six C6 4-4-2 Atlantics arrived; Nos 699 and 704 from Gateshead, 532, 649, 698, and 701 from York. The allocation was now 24 engines and one railcar. Two B16 4-6-0s were also allocated one of which (No. 2371) can be seen in this view in company with A8 4-6-2T No. 2143 during the late 1930s at the straight shed. These B16s were used on passenger trains. although one was used on daily mineral empties to Gascoigne Wood and on a loaded return. During the war some D20s returned to Scarborough until March 1945, when the whole allocation was reduced to 12 locos. Away went J21 0-6-0 No. 582 and 976, and D49 274 to York; J21 1574 and D49 336 went to Leeds; D20 2011, 2018, 2019, and 2021 went to Selby; and A6 688, 689 and 691 went to Starbeck. In exchange came C7 706, 720, 728, 729, 732 and 737 from York, along with 2207 and 2211 from Hull. A8 1502 and 1527 came from Starbeck. 1526 and 1530 came from Selby. As C7s were withdrawn they were replaced by 716, 722, 2166, 2167, 2169, 2204, and 2208. The last to remain at Scarborough was 2207 (now 2992) which was [*continued opposite*]

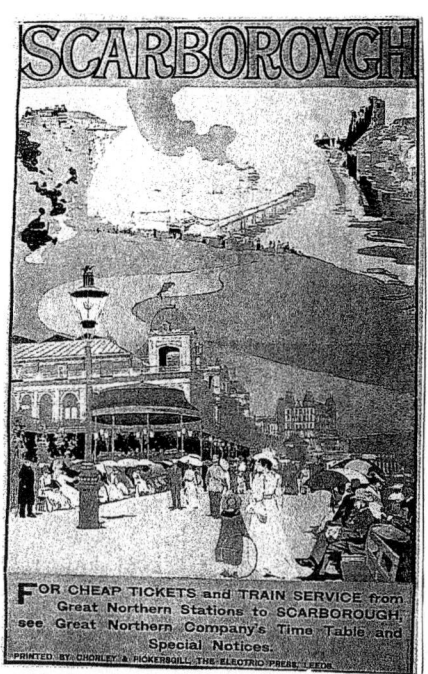

A 1900 poster advertising Scarborough as a tourist destination. (Author's collection)

withdrawn on 1 November 1948, the penultimate loco of the Z Class Atlantics. After the Atlantics had been withdrawn in 1948, they were replaced by D49s, Nos 62746, 62749, 62751, 62755, 62765, 62770, and 62774. Some were soon transferred away, but 62751 *The Albrighton*, 62769 *The Oakley*, 60770 *The Puckeridge*, along with 67726 *The Meynell*, 62739 *The Badsworth* and 62756 *The Brocklesby* became regular top-link locos. The coastline to Whitby, Saltburn and Middlesbrough was worked by Fletcher BTP 0–4–4Ts, followed by Wordsell Class 0 0–4–4Ts. Class W 4–6–0Ts specially built for the line, later rebuilt as 4–6–2T, for greater bunker capacity (Later Class A6) then operated services. Once the line had been extended to Middlesbrough, it became very popular and J39 0–6–0s operated from that town. while Class A8 tanks were used from Scarborough. During the war, A8s were transferred away, but 1502, 1526, 1527, and 1530 came back in March 1945. The line was dieselised in 1958 and the A8s disappeared. Ex-LMS Fairburn 2–6–4Ts. Nos 42084 and 42085 worked the Whitby line in later steam years. During the 1930s, J21s 582, 1516 and 1573 were used as station pilots with a Sentinel shunter operating in the goods yard, later replaced by A6 tanks. From September 1946, new ex-WD J94 0–6–0STs 8016 and 8017 were allocated to Scarborough for goods shunting and in January 1950, J72 69016 replaced the WD engines. It stayed until 1958 when replaced by No. 68739, itself replaced in August 1959 by ex-LMS 3F 0–6–0T No. 47403. After that, any available loco, often 82027, 77004, or 77013, the latter two being BR Class 3 2–6–0s and the former being BR Class 3 2–6–2T. These were replaced by Drewry diesel shunters. (J. Scott–Morgan Collection)

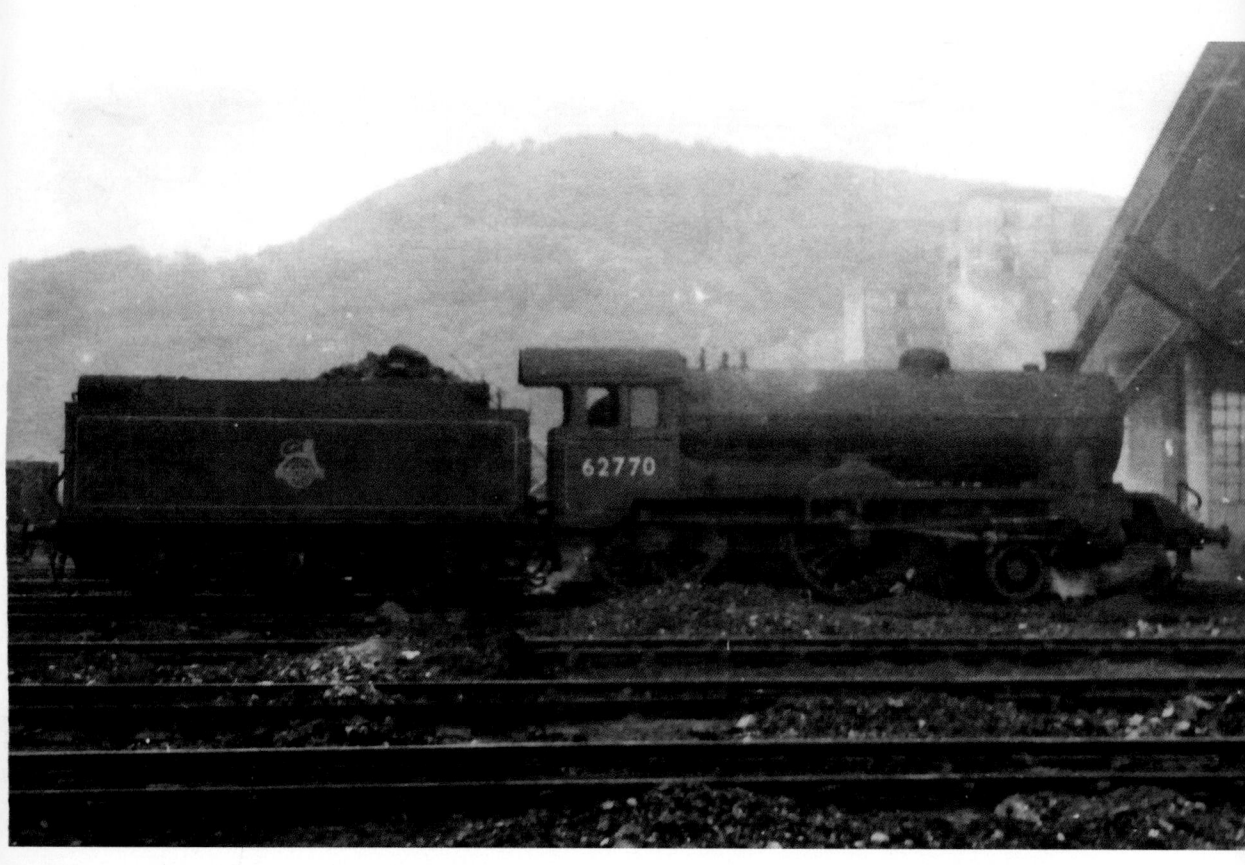

One of the famous D49 'Hunt Class' 4–4–0s allocated to Scarborough shed after the Second World War, No. 62770 *The Puckeridge*, stands outside the shed in the 1950s. The straight shed was built on made-up ground and, in the 1950s, the wall at the east end of the building had to be shored up because of subsidence and eventually half of the building had to be demolished, the shorn up portion can be seen here. A new wall was provided on the south side of the remaining structure, converting the shed into a four-road building, the tracks on the south side being open to the elements. By now, there were only 11 locos allocated to Scarborough shed, as this shows from the allocation of June 1950:

Codes:	LNER	S'BRO	BR 50E
D49	4–4–0	62751	*The Albrighton*
		62764	*The Garth*
		62769	*The Oakley*
		62770	*The Puckeridge*
J39	0–6–0		64919, 64935
A8	4–6–2T		69877, 69881, 69882, 69885, 69886

Total: 11
(LOSA)

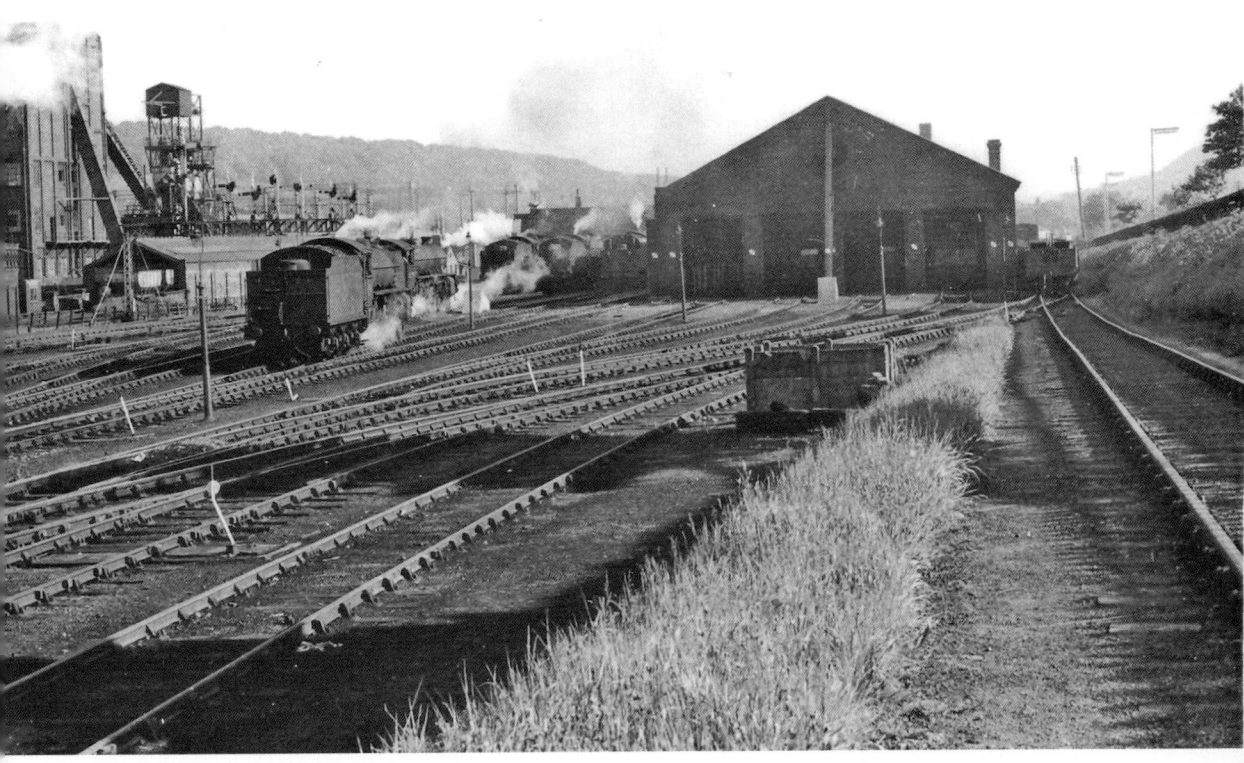

Scarborough loco shed on 2 June 1963. The shed had closed only a couple of weeks earlier, on 20 May, the last engines having departed some two days earlier, with BR Class 3 2-6-2T No. 82027 hauling ex-LMS Ivatt 2-6-2T No. 41265 and BR Class 4 2-6-4T No. 80117. For four years afterwards, turning and watering facilities were used by locos working excursions to Scarborough and for Saturdays only trains. These facilities are being used by several B1 4-6-0s having brought in excursion services. (R. Carpenter)

Another view of the closed Scarborough loco shed on 2 June 1963 with excursion locos in the background. To the left is Scarborough gasworks on Seamer Road. A gasworks has existed in Scarborough since 1836, before the railway arrived, providing gas lighting to the town, along with the railway station, some of which lasted until 1980. Coal for the gasworks would have been transported by the railway and tars, along with other by-products, would have been removed in the same way. The gasworks was taken over by the North-Eastern Gas Board from April 1949, and it closed in the 1970s when natural gas was introduced, making the works redundant. The gas company provided housing for its workers, which still stand today. (R. Carpenter)

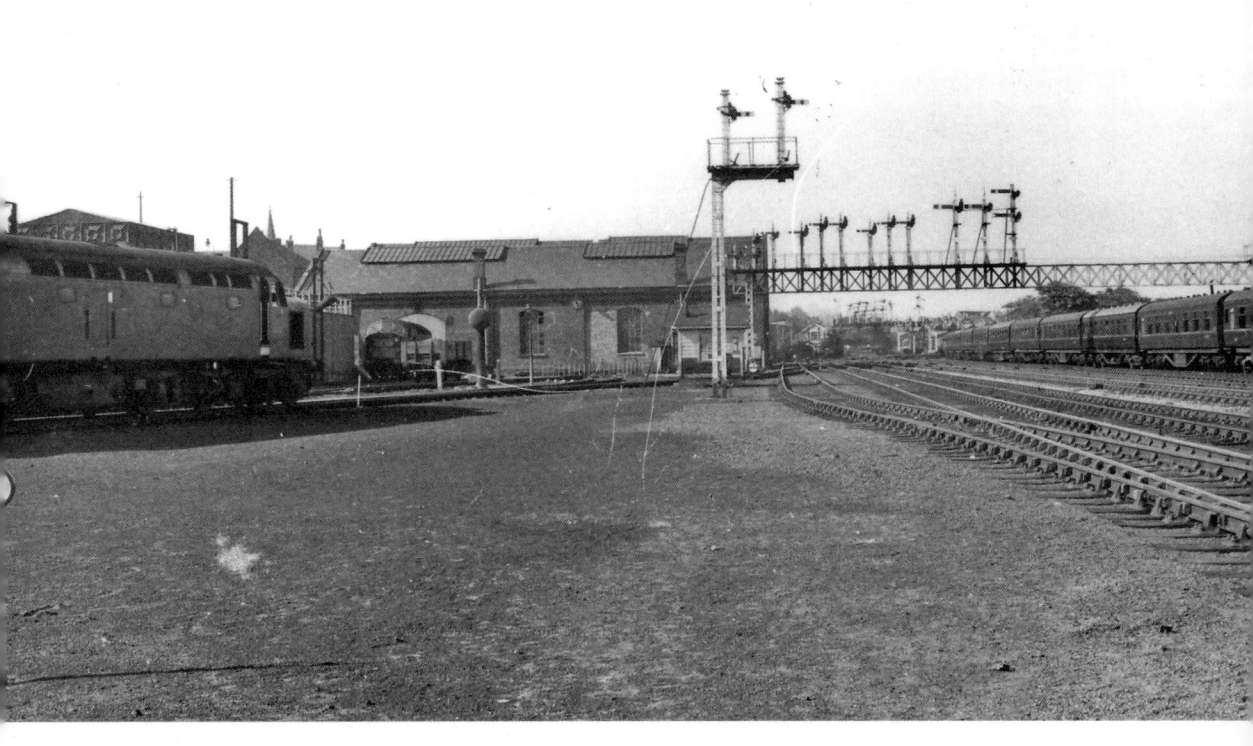

Two English-Electric Type 4 (later Class 40) diesel-electric locos stand behind Scarborough shed on 2 June 1963, with No. D252 in the foreground. It would not be long before all rail traffic would be in the hands of this new motive power and steam traction would, BR hoped, ceased to exist. However, people had other ideas.
(R. Carpenter)

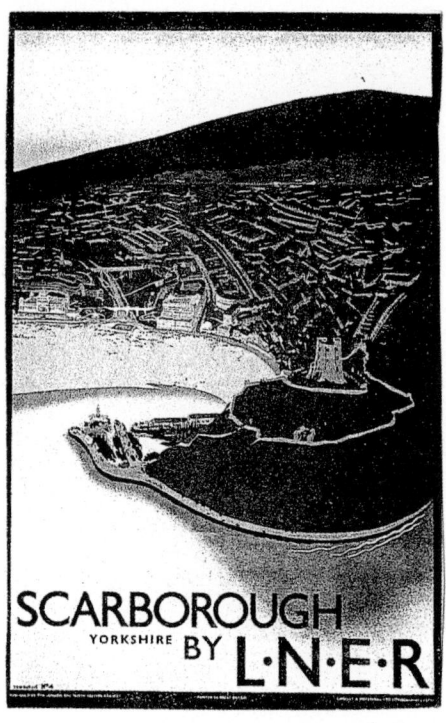

An LNER Art Deco poster for Scarborough of 1936. (Author's collection)

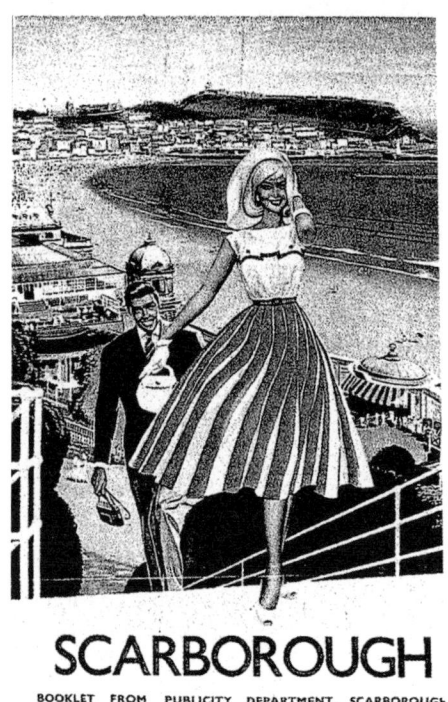

A 1950s advertisement by BR for Scarborough. (Author's collection)

After leaving Scarborough for York, the main line passes Seamer station, the signal box of which can be seen here. The station is a junction for the line to Filey, Bridlington, and Hull and the line to Pickering, closed in 1951, would have branched off to the right. Connections between York–Scarborough and Scarborough–Hull are often made at Seamer and a curve for through running was once considered but the idea was abandoned. (Author's collection)

From Seamer, the main line ran through stations at Ganton, Weaverthorpe, Heslerton, and Knapton before arriving at Rillington, all of these stations are now closed. As can be seen here, Rillington was designed by George Andrews, the Y&NMR Architect, in a style common to the railways in the area. Before final closure, the station lost its overall roof. From Scarborough, before entering Rillington, the branch to Pickering and Whitby turned off to the north, with a short-lived curve, some half mile closer, which once allowed through running from Whitby to Scarborough and had been installed in 1865. (LOSA)

35

An NER timetable of 1910 for trains between Scarborough and York. (Author's collection)

An NER timetable for trains between Scarborough and York in 1922, less than a year before the 'Grouping' of 1923 when these services were taken over by the LNER. (Author's collection)

Malton station on 25 April 1958 with ex-LNER A8 4-6-2T No. 69861 waiting with a local train for Whitby, via Rillington and Pickering. Malton station was designed by George Andrews, opening in 1845. The station is actually in Norton, on the south bank of the River Derwent. With opening of branches to Thirsk and Driffield, Malton began to become an important railway centre. East of Malton, the Driffield branch went off southwards and, until September 1962, this line was used as far as Scarborough Road Junction by trains from Scarborough to the north, via Gilling, which reversed at Scarborough Road and then climbed over the Malton–Scarborough line, along with the River Derwent. (R. Carpenter)

Ex-LNER G5 Class 0-4-4T No. 67308 stands outside Malton loco shed on 25 April 1958 with an interesting pair of coaches, which look as though they are of NER vintage. Malton shed, like the station, is actually in Norton. A tender for construction of a loco shed here was accepted in August 1853 and was for £435. By 1865, plans were made to extend the buildings providing accommodation for an extra six engines. In 1866, a new shed was proposed at a cost of £6,817. In February 1867, a suggestion was made for the existing shed to be extended as accommodation for two extra locos was required, this plan was accepted, at a cost of £800. Further work was carried out in 1870 when it was decided that the shed, turntable, and coke shed should be lit by gas, along with a crane and tubs being provided to coal engines: this method being used until the shed closed on 15 April 1963. Malton was once an important centre, with branches to Whitby, via Pickering; Driffield, and Pilmoor from the York–Scarborough main line, its allocation working branches, together with goods trains between Malton and York. To cover services there were nine daily goods duties and four daily passenger turns. Malton was also responsible for assisting Scarborough–Newcastle and Glasgow trains between Malton station and Scarborough Road Junction. These trains needed to reverse at Malton to gain the Gilling–Pilmoor line and the complete train, with the train engine at the rear, was hauled by the Malton engine between the station and Scarborough Road Junction. The train engine then took over, with the Malton loco providing assistance on the climb to cross the Scarborough line and River Derwent. In the reverse direction, the Malton pilot was coupled to the rear of the train from the north and hauled it into Malton station with the train engine in the correct position

for working forward to Scarborough. Malton shed also provided an emergency loco on summer Saturdays when traffic was at its heaviest. Often, a loco was borrowed from York or Selby as Malton had no allocation of express engine, although a J39 0–6–0 could be used if necessary, the J39s being allocated in the 1950s. The J39s, along with J27 0–6–0s, were responsible for freight workings, including the important morning mineral train to Thirsk, conveying limestone from quarries on the Driffield branch. Often, two trains were run and Malton acquired various classes of loco for the job, including A7 2–6–4Ts, Q5 0–8–0s, and WD 2–8–0s. Prior to these allocations, ex-NER P and P1 0–6–0s were used, the most notable being Stockton and Darlington pattern long boilered 0–6–0 No. 1275, built by Dubs in 1874, the only member of the class remaining when the LNER was formed. It left Malton in February 1923, eventually being preserved at the railway museum in York. As dieselisation took hold and traffic declined due to closure of the branches, Malton shed was scheduled for closure, becoming effective in April 1963.

Locos allocated to Malton at closure were:

Ex-LMS 2MT 2–6–2T	41251
BR 3MT 2–6–0	82027, 82028, 82029.
Ex-LMS 2MT 2–6–0	46413, 46473.
Ex-LNER J 27 0–6–0	65844, 65849, 65888

Compare that to the allocation for June 1950:

Code: LNER–MLTON,	**BR–50F**
D49 4–4–0	62774 *The Staintondale*
J24 0–6–0	65600, 65631, 65636, 65640, 65642, 65644
G5 0–4–4T	67273, 67275, 67330, 67332, 67349
Y1 0–4–0T	68150
Y3 0–4–0T	68157

Total: 14

At closure, all locos, except 46413 (which went to Goole), were sent to York. The last working from Malton shed was the afternoon return to Whitby, headed by ex-LMS 4MT 2–6–0 No. 43055 on 13 April 1963. The shed has since been demolished and no sign of it now exists. (R. Carpenter)

TWO

RAILS TO WHITBY

While a direct rail link between Scarborough and Whitby did not come into existence until 1885, Whitby was the first town in this part of Yorkshire to be rail connected when a line between here and Grosmont was opened on 8 June 1835 as part of a route going as far as Pickering. The remainder of the line between Grosmont and Pickering was completed and opened on 26 May 1836.

A railway from Whitby was deemed important because the town was concerned about decline of traditional industries of shipbuilding, whaling, and alum working. It was felt that trade would improve if there was better inland communication and, with this in mind, a meeting was convened at the town's Angel Inn in May 1831. As a result of this meeting, George Stephenson was asked to survey a line which would be simple to construct and could use animals to pull trains. He reported that a line to Pickering would suit their needs as it could be used to transport coal and other goods from the sea inland to the Vale of Ryedale, while agricultural produce and building stone could be sent to the coast for onward shipment, thereby generating profits on money invested on construction of the railway.

An Act to incorporate the Whitby and Pickering Railway was obtained on 6 May 1833 and the contract for construction was let in August 1833. Work proceeded well despite the isolated and difficult terrain through the North Yorkshire Moors. A tunnel, with castellated entrances, fourteen feet high and ten feet wide was built at Grosmont, while problems of laying track at Fen Bog (between Newton Dale and Goathland) was solved by using sheaves of heather bound in sheepskins, along with whole trees and hurdles covered with moss to provide a firm foundation. Total construction costs were £105,000, more than double the original estimate, for the whole 24 mile line. Trains were drawn by a single horse over the original Whitby–Grosmont section when it opened in 1835, carriages looking like stagecoaches (a design used by the Liverpool and Manchester Railway when it opened in 1830).

When the whole line opened, trains were horse drawn to Beck Hole from Whitby and then hoisted up the incline there by six-inch thick hemp rope wound around a revolving drum at Bank Top station, the climb taking around five minutes. Once over the summit, gravity took coaches down to Newtondale (at speeds of up to 30 mph) from where they were horse-hauled for the final four miles to Pickering. When regular

services commenced, there were two trains each way per day, many passengers using the line just to experience the incline between Beck Hole and Goathland.

In 1845, the line became part of George Hudson's empire, when the Y&NMR purchased it for £80,000 so that Whitby could be developed for tourism. The line was rebuilt for steam locomotive haulage, with heavier rails, track doubling, and tight curves eliminated. A stone bridge and larger tunnel were constructed at Grosmont and five timber bridges were replaced by iron. New stations were built at Whitby and Pickering, with more permanent structures erected at intermediate stopping places. Hemp rope on the Beck Hole incline was replaced by wire, with engine sheds being constructed at the foot of the incline. By 1845, Pickering was connected to the rest of the railway network when a branch was opened from Rillington (on the York–Scarborough main line) and Grosmont became a junction station on 2 October 1865 with opening of a line along Eskdale to Castleton, where it connected with existing railways to Middlesbrough.

A second line from Whitby was started in 1871, following an Act of 1866 which incorporated the Whitby, Redcar, and Middlesbrough Union Railway. The line followed what was considered to be the most scenic railway routes in England for 10 miles from Whitby West Cliff to Staithes along cliffs above the North Sea. Due to a late start on construction, a new Act was needed in 1873 to complete the line to Loftus. However, in 1874, the contractor went into liquidation and the line was leased to the NER (who were to take it over completely in 1899). The NER found previous work so unsatisfactory (bridges defective, piers out of vertical, and tunnel surveys out of line) that much work had to be done again. Part of the proposed line was so dangerously close to the cliff edge the NER abandoned it and took a route further inland through Sandsend and Kettleness. Further problems were caused by the fact that deep valleys dropped down to the sea and four viaducts were required on the stretch to Sandsend, with a further large one at Staithes (790 feet long with seventeen spans and standing 150 feet above Roxby Beck). All bridges were tubular cast iron frameworks filled with concrete, rather than loose gravel used by the WR&MU at the statt. Staithes bridge was still unfinished when the Tay Bridge disaster occurred in 1879, which meant that the Staithes viaduct had to be strengthened with extensive cross bracing. A wind gauge was also provided, although it proved to be rather unreliable. These problems, along with construction of Grinkle Tunnel near Loftus, meant that it took twelve years to complete the line.

The line was opened without ceremony on 3 December 1883, but there were so many passengers for the first train from Whitby that extra carriages had to be provided and many passengers travelled without tickets. There were stations at Whitby West Cliff, Sandsend, Kettleness, Hinderwell, Staithes and Easington (Grinkle from 1904) before the line made an end-on connection with the former Cleveland Railway at Loftus station. First services started at Whitby Town and Whitby West Cliff to Middlesbrough until the line from Scarborough opened, creating a Scarborough–Whitby West Cliff–Saltburn service, a reversal or shuttle service being required into Whitby Town.

The final line into Whitby was the route from Scarborough, its origins beginning with an Act of 5 July 1865. However, insufficient capital was raised and nothing was done for five years. In 1870, a scheme was put forward for an isolated line from Gallows Close, Scarborough to Gideon's Timber Pond (via a one-in-five-and-a-half incline) on the east side of the River Esk at Whitby. Royal Assent was given on 29 June 1871 and the Scarborough and Whitby Railway was authorised to raise capital of £120,000. Work commenced near Scarborough cemetery on 3 June 1872, the Engineer being Eugenius Birch and contractors were Kirk and Parry.

The first seven miles from Scarborough were ready for ballast and track by August 1873 and an Act had been obtained authorising a junction with the NER at Scarborough and the WR&MU at Whitby. Progress was slow, and, by 1877, work was stopped due to lack of funds. Indeed, a group of shareholders wanted the receivers in to wind up the company.

New efforts to complete the line were made in 1879, and an Act was passed on 12 August 1880 to revive powers to complete the line and raise further capital. New engineers, Sir Charles Fox and Son of Westminster, were appointed while John Waddell and Sons of Edinburgh become contractors. Work was recommenced in 1881, the line being completed and opened to traffic on 16 July 1885. Due to difficulties associated with construction, the cost of building the line had risen from an estimated £157,000 to £649,813.

With the opening of the Scarborough–Whitby line, the railway system around Whitby was complete and would allow development of tourism, as well as industry, in the town.

As the First World War drew to a close, the NER, along with the other railway companies, began to advertise holiday resorts once again, aware that with cessation of hostilities there would be need for relaxation and 'fun', along with trips to the seaside to escape the drudgery associated with a wartime economy. Here, a 1918 poster extols the virtues of Robin Hoods Bay. (Author's collection)

An LNER poster advertising Whitby and featuring famous son Captain James Cook, emphasising the resort's link with seafaring and discovery of the 'New World', providing an extra attraction for tourism which would benefit both the town and the railway company. (Author's collection)

A 1930s poster for Whitby emphasising its strong links with the sea. The 'Then' portion shows the link with the town and Captain Cook, who discovered Australia, among other nations on the other side of the world, while the 'Now' portion shows how much the sea means to the town and its links to tourism. (Author's collection)

An LNER poster for Whitby, showing the town as it appeared in the 1930s. (Author's collection)

Ex-NER O Class 0–4–4T, now LNER G5 Class No. 2097 at the head of a local train, Whitby station June 1934. The overall roof and main building was designed by George Andrews and constructed after the line from Whitby to Pickering had been taken over by the NER. When the line to Pickering was opened passenger traffic exceeded all expectations, with 3,903 passengers carried in July 1836 and another 4,200 in August. In six months during 1837, the total number of passengers carried was 8,000 more than the previous six months. In the town itself, such was the success of the new railway that the Whitby Harbour Commissioners had to make improvements to the port due to increases in trade, seabourne coal to Pickering led to the establishment of two new companies dealing with large increases in traffic. Pickering benefited by effects to trade when cargoes from London reached the town within three days. Limestone was sent by the new railway from Pickering to new kilns built at Grosmont and stone from quarries in the Goathland area was rail-borne and used in construction in London of such buildings as Covent Garden and Somerset House. The existence of the railway led to the birth of the Cleveland iron industry when, in 1836, a partner in the Tyne Iron Company found an outcrop of ironstone at Grosmont and convenient access to a port allowed this traffic to be worked by the Whitby Stone Company.
(R. Carpenter)

LNER G5 loco. No. 1889 waits to depart Whitby station with a local train for Malton, via Pickering in June 1934. These engines replaced BTP 0–4–4Ts which operated autocar trains from 1905 and had even worked Middlesbrough–Whitby passenger services along with Wordsell 0–6–0 tender engines from 1884. Despite initial success, the railway was in financial difficulties from the start, partly caused by the estimated and actual cost of building the railway. A meeting held at the end of 1836 was informed that the new line was in debt to the tune of £13,000 and on 5 May 1837, an Act was obtained to raise £30,000 extra capital. It was also found that it was uneconomical to transport ironstone from Grosmont to Whitby, as it took 20 horses and 10 men to transport 120 tons of the stone. In 1845, the Y&NMR purchased the Whitby and Pickering Railway for £80,000; around £25,000 less than the cost of construction and the new owners began rebuilding the line to make it suitable for steam loco haulage. Heavier rails were laid, some sharp curves were altered and sections of track were doubled. A stone bridge and larger tunnel (to replace the small original) were built at Grosmont and five timber bridges were replaced by iron ones. New stations were built at Whitby (the one in this view) and Pickering. (R. Carpenter)

Sentinel steam railcar, *Britannia* with ex-GNR coach attached, at Whitby station in June 1934. This 100 hp six–cylinder railcar was shedded at Stockton at this time and had probably worked from Middlesbrough to Whitby. These six–cylinder cars were also used on local services and on shuttles between here and West Cliff station, following opening of the line from Scarborough to Saltburn and Middlesbrough which avoided Whitby Town station altogether. When traffic was heavy during the summer season, two cars would be coupled together on the shuttle service, the only line on the NER section where: this was the practice, from 1935. This particular railcar ended its life at West Auckland and was withdrawn in September 1944. It was George Hudson who set about developing Whitby, by purchasing West Cliff fields and building terraced boarding houses, but he was never to fully realise his plans due to his fall from grace following dubious financial practices. The foundations were, however, laid and the town went on to become an important seaside destination, much to the benefit of local railways. (R. Carpenter)

WHITBY

IT'S QUICKER BY RAIL

FULL INFORMATION FROM L·N·E·R OFFICES AND AGENCIES

A railway poster for Whitby of the 1930s showing the ruins of Whitby Abbey, a prominent feature of the town and a major tourist attraction. (Author's collection)

THE BUILDING OF "THE EARL OF PEMBROKE" (CAPTAIN COOK'S "ENDEAVOUR") 1764.

WHITBY AN ANCIENT PORT AND MODERN RESORT

IT'S QUICKER BY RAIL

Illustrated Guide free from L·N·E·R Offices and Agencies or Department A, The Spa, Whitby.

A poster featuring Whitby which features the construction of *The Earl of Pembroke*, which was to become Captain Cook's ship *The Endeavour* and emphasising the towns history with the slogan 'An Ancient Port and Modern Resort'. (Author's collection)

Ex-LNER Thompson B1 4–6–0 No. 61049 is seen bringing in a train to Whitby station in the 1950s. These locos, with six feet two inch driving wheels were built between 1942 and 1950. They were built to replace GNR, GCR, and NER 4–4–2s, GCR 4–6–0s and various 4–4–0s. A total of 410 were built, but one was scrapped following a collision at Chelmsford in 1950. These engines were an amalgamation of several pre-War Gresley designs:

The cylinders were from K2 2–6–0s, the driving wheels were from V2 2–6–2s, and the boiler was a Gresley design from April 1939, although pressure was increased from 220 psi to 225 psi. The chimney was taken from Gresley's O2 class of 1923 and the tender was almost the same as Gresleys K3 Class. The B1s appeared all over ex-LNER main lines around Scarborough and often worked 'The Scarborough Flyer' and holiday services to Whitby, Filey, and Bridlington as well as to Scarborough itself. (LOSA)

Ex-LNER A8 4–6–2T No. 69869 is shunting at Whitby goods yard on 15 July 1956. With the harbour in the foreground, and the town with its abbey on the hilltop in the background, it is little wonder that the town became such a magnet for tourists, the town also giving access to the North Yorkshire Moors which was also well served by the NER/LNER/BR(NE) Region. During the first half of the twentieth century, rail traffic to Whitby increased rapidly, especially during the 1920s and '30s. Especially popular were Sunday scenic excursions from places like Leeds and Bradford which were worked outward via Pickering to arrive in Whitby by lunchtime. The trip then continued along the coast route to Scarborough in time for tea before returning home via Seamer and Malton. (R. Carpenter)

Ex-LNER J25 0–6–0 No. 65663, and fitted with a snowplough, is outside Whitby shed on 15 July 1956. These locos were built between 1898 and 1902 by the NER, as Wilson Wordsell's P Class. 120 of these engines went into service. As they were pure freight engines, they had no continuous brakes. Ten of these engines were still running in 1961, but all had gone by 1962. A shed at Whitby was probably built by the Y&NMR in 1847 when steam locos began operating between Whitby and the foot of Goathland Incline, replacing horse drawn vehicles of the Whitby and Pickering Railway. In August 1865, plans were prepared for a shed to hold eight engines. In February 1867, a report suggested that the expense of a new shed could be avoided if the existing building was extended to hold a further four locos. This was approved, and a tender of £1,570 3s was accepted in March 1867. Objections were made in May concerning the height of the new extension which delayed opening until the end of 1868. No further alterations were made, although extensive repairs were undertaken in 1903 and a dividing wall was removed. A plan of 29 September 1900 proposed a single square roundhouse to be built at Ruswarp (on the line to Grosmont) to replace the shed at Whitby but the scheme came to nothing. Whitby shed provided motive power for four routes radiating from the town, these were:

1) To Saltburn via Loftus
2) To Middlesbrough via Battersby
3) To Malton via Pickering
4) To Scarborough via Robin Hoods Bay

For many years, 4–4–0s were used on these lines, the practice starting in 1864 using Fletcher 'Whitby Bogies' – a short wheelbased 4–4–0 specially designed to negotiate tight curves through Newton Dale. Later, McConnell Class 38 4–4–0s were used. These were followed in early LNER days by Wordsell G Class 4–4–0s. These were followed by various classes of tank engines; from F8 2–4–2Ts through G5 0–4–4T, A6 2–6–4T (The famous Whitby Tanks), A8 4–6–2T, BR 4MT 2–6–4T, and LMR 4MT 2–6–4T. The G5 locos worked in the area right up until the 1950s. (R. Carpenter)

Ex-NER/LNER J25 0–6–0 No. 65700 at Whitby shed on 22 August 1954. Excursions to Whitby brought D17/1, D20, D21, and D49 4–4–0s to the shed, along with the unusual sight of ex-GNR Class C1 Atlantics. In 1955, Whitby received five BR Standard 2–6–4Ts new from Brighton These were replaced by ex-LMS 2–6–4Ts Nos 42083, 42084, and 42085 and these were the last locos, along with BR 3MT 2–6–0s Nos 77004, and 77013, to be stationed at Whitby, when the shed closed on 6 April 1959. The shed was subsequently used as a fish packing warehouse. In happier times, the shed's allocation for June 1950 was as follows:

LNER Code,	BR Code–5OG
J24 0–6–0	65621, 65624, 65627, 65628
G5 0–4–4T	67302, 67335
A8 4–6–2T	69858, 69860, 69861, 69864, 69865, 69888, 69890
Total: 13	
(LOSA)	

In the 1930s, particularly during the summer months, Whitby had an allocation of ex-Hull and Barnsley Railway Class B (LNER J28) 0–6–0s designed by Matthew Sterling and introduced in 1900. These engines originally had domeless boilers, continuing the practice of his uncle, James Stirling whom he succeeded as CME of the H&BR and his father Patrick, both of whom built locos with domeless boilers. These engines had been displaced by larger engines at their home sheds. First to arrive was 2476 from Hull Springhead on 7 July 1930, No. 2440 followed from Cudworth two weeks later. Two from York, supposedly for the summer only, followed in July 1931 (Nos 2459 and 2522). Two years later, 2469 (ex-Springhead) replaced 2440 when it was withdrawn.

In June/July 1934, 2460 from Springhead and 2477 from Cudworth arrived. No. 2459 was withdrawn in 1933 and in July 1936 No. 2469 was transferred to Hull Dairycoates to release J21 No. 981 to Darlington. Locos Nos 2460, 2476, and 2522 remained at Whitby until ex-H&BR engines were scrapped in 1937/8. These locos worked passenger trains to Malton, with some trains being extended to York and Leeds in the summer. During the winter months, these engines were used on goods trains. In this view, Nos 2469 and 2460, with original domeless boilers, are visible in the background and No. 2477 with LNER domed boiler sits in the foreground at Whitby. (R. Carpenter)

Leaving Whitby Town station, the line to Pickering follows the course of the River Esk, passes under Larpool Viaduct as it climbs towards Ruswarp station. This section to Grosmont was once double track and is now part of the 'Heritage' Esk Valley line to Middlesbrough. Here, a handsome Ruswarp station is seen in a picturesque setting on the North Yorkshire Moors. (LOSA)

Continuing along the 'Esk Valley' line, the handsome station at Sleights is approached, serving a very attractive and steep fishing village, which is still very much a tourist attraction. The station is seen here in NER days. (LOSA)

An LNER Sentinel Steam Railcar enters the tunnel at Grosmont in the early 1930s. (R. Carpenter)

An aerial view of the village at Grosmont showing the sidings and railway station in the distance. Just before the wagons come into view is the mouth of the tunnel built by the Y&NMR, replacing the earlier original. Both are still in existence—the newer one being part of the preserved North Yorkshire Moors Railway, while the older structure gives access to the loco shed established here when the line was preserved. Grosmont became a junction when the Esk Valley line was opened to Castleton on 2 October 1865 and the tracks to the junction can be seen in the distance. The wagons just beyond the tunnel are connected with the ironworks here, which were opened around 1863 and blast furnaces produced iron until 1891. It took four locos to cope with product from the works at its peak. (LOSA)

Beckhole Auto-Car Station

After the Y&NMR took control of the Pickering–Whitby line, plans were made to eliminate the incline at Beck Hole, not least because there had been accidents, in 1861 and 1864, when rope hauling trains up the incline had snapped, killing two passengers and injuring 13 more in 1864, only goods traffic had been affected in the other incident. The new deviation, which eliminated the incline took four years to construct, although it was less than five miles long, and cost some £50,000. New bridges had to be built and two farmhouses had to be demolished. A new station was built at Goathland, the 1 in 49 deviation finally opening on 1 July 1865. During the Edwardian period, the original line from 'Deviation Junction' to Beck Hole was brought back into use as a tourist attraction during the summer months from July 1908, being served by an autocar and railcar service. This view shows the autocar service train with a BTP 0–4–4T as motive power. (LOSA)

The first railcar service at Beck Hole is celebrated with this 1908 picture with passengers posed in their finery of the day. Summer visitors came in their numbers to enjoy the nearby waterfalls and visit local tea gardens. Outbreak of the First World War saw these trains withdrawn, never to return. (LOSA)

Goathland station in NER days, showing wagons full of stone from the nearby quarry at Silhowe. This is the station opened in 1865 as part of the investment in the Deviation line. The little station is complete with signal box and goods shed. A water tower is situated here for locos collecting stone wagons from the siding. (LOSA)

A view of Goathland station in NER days showing the sidings serving the nearby quarry. The village can be seen in the left background and has become famous as 'Aidensfield' in the television series 'Heartbeat'. The station features regularly in the TV series, its typical NER main building a recognised feature. The station also serves as 'Hogwarts' station in the 'Harry Potter' films. (LOSA)

Ex-Hull and Barnsley Railway Class B, LNER J28, 0–6–0 No. 2453, with LNER domed boiler, heads a freight train past the water tower at Goathland station in June 1934. The quarry workings can be seen in the background. (R. Carpenter)

Near Levisham station is ex-H&BR J28 loco with original domeless boiler, on an Engineers train during the early 1930s. (R. Carpenter)

Approaching Levisham station from Pickering an unidentified 0–6–0 loco heads a goods train through the picturesque North Yorkshire Moors on its way through to Whitby in NER days. (LOSA)

The main station building at Levisham in NER days. The station here is sideways on to the platform and is an original structure dating back to the days when this line was horse drawn. (LOSA)

The Station Pickering.

3493.

Pickering station looking towards Mill Lane Junction with an unidentified NER 0–6–0 at the head of a passenger train, probably from Malton. The scene was in early LNER days, given that the station sign is of LNER design. This was the station built by the Y&NMR in 1845 and was designed by George Andrews. The station was given an overall roof, like many market town stations in NER days. The station was lit by gas, with the company's own gasworks in the goods yard. The station lost its roof in 1952, with small canopies as replacements. Pickering became a junction in 1875 with the completion of the branch from Kirkbymoorside, joined some seven years later by the Forge Valley line from Seamer. (LOSA)

Pickering shed, a subshed of Malton, seen in LNER days with a Sentinel Y3 shunter operating outside. The original shed here was probably built by the Y&NMR when they took control of the line. An extension was planned in October 1874 so that two engines could be accommodated instead of one. This extension was completed in 1876, at a cost of £604 2s 6d and the shed remained unchanged until closure on 6 April 1959. Until 1923, when replaced by two G5 0-4-4Ts, BTP 0-4-2Ts were used to operate services, with J22 0-6-0s on goods turns, and mainly shunted at Pickering. One G5 was transferred away in 1928 and J21 No. 491 was scrapped on 23 January 1929. In 1928, Pickering received one of the first two double-geared Sentinel locos bought by the LNER. As No. 81 (the loco in this view) it was used for local shunting. This particular engine was fitted with a vacuum brake, the idea being that a Y3 at Pickering could be used on a passenger train to Scarborough if the Sentinel steam railcar could not operate the service. The occasion never actually arose, although trials were carried out between Pickering and Seamer with No. 81 hauling one or two coaches. No. 81 was replaced by No. 192 in September 1942, this Sentinel remaining at Pickering until withdrawn in December 1952. In February 1930, J21 0-6-0 No. 1809 arrived from Normanton, being replaced six months later by ex-H&BR 0-6-0 No. 2453. After complaints of having to run tender first, the shed received N8 0-6-2T No. 218 on 30 August 1934, 218 itself being exchanged for No. 76, a superheated loco, in November 1934. The only G5 at Pickering was transferred to Malton, along with H&BR 0-6-0 No. 2453 on 31 July 1935. On 22 January 1938, No. 76 went to York and N9 No. 1645 from Tweedmouth took its place. It went to York a year later with No. 76 coming back to Pickering. On 16 November 1940, D20 4-4-0 No. 1232 arrived from York in exchange for No. 76. In December 1941, G5s 1755 and 1888 went from Malton to Pickering, with 1232 going to Darlington a few weeks later. G5 1888 returned to Malton at the end of June 1942 with 1755 following later, Pickering only having the Sentinel engine until 1948, when D49 No. 62774 'The Staintondale' came to Pickering for a three year stay. It was replaced in September 1951 by D20 4-4-0 No. 62343. This loco stayed until February 1953 when it was replaced by G5 No. 67308, which was withdrawn on 22 November 1955 and all locos were then supplied by Malton shed until Pickering shed finally closed. (Beck Isle Museum, Pickering)

63

The interior of Pickering shed with NER Wordsell Class R 4-4-0, LNER D20 No. 2018, being serviced. The loco was probably used on service from York. The shed, coded P'KING in LNER days and 50F in BR days, supplied engines for passenger duties to York and back, via Pilmoor and to Scarborough, via the Forge Valley line. (Beck Isle Museum, Pickering)

Although Pickering shed closed in 1959, it is one of the few country sheds to remain in existence, albeit as a workshop. It is, however, separated from the preserved railway by a new road system. The abandoned shed can be seen here on 2 June 1963 before it found a new use as a timber and joinery workshop. (R. Carpenter)

Marishes Road station, on the line between Rillington and Pickering. This little branch connected the Whitby–Pickering Railway with the main Scarborough–York line and allowed local passenger services between Malton and Whitby. For the first eight years of its existence, the Whitby to Pickering line remained isolated from the Y&NMR (later NER) network, although from as early as 1834, George Stephenson had surveyed two routes from Pickering to York, one via Malton and the other via Easingwold, but these projects did not go any further, probably due to the overrun on costs involved in construction of the Whitby–Pickering line. George Hudson then Chairman of the Y&NMR, was concerned that the Whitby and Pickering Railway could be left totally isolated and, for this reason alone, could cease to become a financial success. Thus, in 1840, he persuaded shareholders of the W&PR to spend £500 of its profits to survey lines from York to Scarborough and Pickering. The directors of the W&PR initially considered amalgamation with the Stockton and Darlington Railway but settled for the Y&NMR, who eventually took control of the W&BR and by 1845, the Whitby line was connected to the main network at Rillington, with this attractive little station at Marishes Road the only intermediate stop between Rillington and Pickering, a local train is seen departing in NER days with a small tank loco, possibly a BTP 0-4-4T, providing motive power. (LOSA)

At the start of the line to Loftus is the station at Whitby West Cliff seen here on 4 September 1957 with ex-LNER A8 Class 4-6-2T No. 69865 at the head of a train for Scarborough and another of the same class, No. 69885 is approaching the station with a train bound for Saltburn. The station here changed very little over the years, only the addition of a bay platform to accommodate the shuttle service between here and Whitby Town was the only alteration. Up until 1932, there were six weekday trains each way between Whitby and Loftus. The following year, however, passenger numbers increased substantially due to the introduction of cheap 'Runabout' excursion tickets and a change in coastal services. Services now terminated at Middlesbrough, via Guisborough, and gave Teesside better access to Whitby and Scarborough. By the peak summer of 1939, there were 13 trains each way every day, plus two extra on Sundays, along with reliefs and excursions. The line would have been very busy indeed. Indeed, the single line section, with passing loops at five stations struggled to cope with demand, but Grinkle station was little used and closed in September 1939, just after outbreak of the Second World War. (R. Carpenter)

Approaching Whitby West Cliff on 24 April 1958 is A8 No. 69876 with a train for Scarborough. The A8 4–6–2Ts were rebuilt from NER 4–4–4Ts of the D Class which had been designed by Vincent Raven at Darlington and introduced in 1913. These engines were designed to be as good running bunker first as well as chimney first. The tanks held 2000 gallons of water and the bunker four tons of coal. The boiler barrel was 11 feet long and 4 feet 9 inches in diameter, with an eight-foot-long firebox, giving a grate area of 23 square feet, making them large engines for their time. A Schmidt superheater was fitted, giving a total heating surface of boiler and firebox some 1,253 sq ft. Boiler pressure was 175 psi and fed three 16½ x 26 inch cylinders (one inside and two outside) with seven-and-a-half inch piston valves activated by Stephenson's link motion. These engines had five foot nine inch driving wheels with front and rear bogies having three foot one-and-a-quarter inch wheels. The locos weighed 87 tons 7cwt, of which 39 tons 19 cwt was available for adhesion. Originally, 30 engines were ordered from Darlington, but only 20 were built, due to the intervention of the First World War in 1914. These engines went to Newcastle, Leeds, and Saltburn. Their most difficult route was the Saltburn–Whitby–Scarborough line. This line, however, was not ideal for 4–4–4Ts due to the 1 in 41 and 1 in 39 gradients to Ravenscar, the 1 in 43 climb out of Robin Hoods Bay, and the 1 in 57 climb through Sandsend Tunnel. The engines were quite quick and free steaming when conditions were good, but they would slip on greasy rails and needed careful handling on steep gradients and tight curves, which were encountered on the Whitby–Scarborough line. The engines were reclassified H1 following the 'Grouping'. The former NER lines needed more large-tank engines and the new CME, Nigel Gresley, opted to have 13 ex-Great Central 9N Class 4–6–2Ts built for the NER lines. So surefooted were these engines that, in 1928, seven were sent to Saltburn to replace the H1s on Darlington services. These H5s proved successful, with superior adhesion over the H1s, and Gresley had H1 4–4–4T No. 2162 converted into a 4–6–2T in 1931. This was the first of the A8 class pacific tank engine. No. 2162 was tested extensively over the NER and had superior adhesion and surefootedness over the 4–4–4 tanks on the Whitby–Scarborough line. Thus, all H1 tanks were converted to A8 tanks at Darlington between May 1933 and August 1936, many finding their way on to the Whitby–Scarborough line to assist the A6 'Whitby Tanks', and on the Whitby–Pickering–Malton lines until replaced by diesels Multiple Units from 1958. While the H1s were being rebuilt, J36 0–6–0 locos were used on heavy summer trains in 1933 until a derailment precluded their use, meaning that the A8s had to be drafted on to the route as soon as they could be rebuilt at Darlington works. (R. Carpenter)

On 24 April 1958, BR Eastern Region L1 class 2–6-4T No. 67765 is seen on a passenger train near Whitby West Cliff. These locos were built between 1946 and 1950 and had two cylinders with 5 feet 4 inch driving wheels. As well as these and the A8s, other passenger tank types operated between Scarborough, Whitby, Saltburn, and Middlesbrough in steam days, including A6 4–6–2 'Whitby Tanks' which had been built between 1907 and 1908 as 4–6–0Ts. They were converted to a 4–6–2 wheel arrangement to increase coal space in the bunkers. Unlike the A8s, these engines had two inside cylinders. In 1943, LNER V1 and V3 2–6–2Ts appeared in Whitby and Scarborough workings after restrictions on their use south of Loftus had been removed. (R. Carpenter)

One of the major features of the Whitby–Saltburn line was the viaducts which carried the railway over some deep valleys between Whitby West Cliff and Staithes. These viaducts were built of tubular steel and looked rather spindly. The first such structure was Upgang Viaduct, just north of West Cliff station. The viaduct was 330 feet long and 70 ft high, with five 60 ft spans and one of 27 ft 6 in. Extensive repairs were needed in 1893–94. Here, L1 Class 2–6–4T No. 67764 heads a Scarborough–Whitby–Middlesbrough train on 24 April 1958. (R. Carpenter)

Following on from Upgang Viaduct was Newholme, sometimes called Newholme Beck, viaduct. This viaduct was also 330 feet long with a height of 50 feet and had nine 30 foot spans and two of 57 feet 6 inches. The viaduct is seen here in June 1934 with ex-H&BR J26 0–6–0 on a short freight train. There was plenty of freight traffic for the NER/LNER in the locality, due to quarrying of stone. Along with limestone, there were shales at Whitby and sandstone at nearby Staithes. An important source of traffic, albeit in small quantities, was Whitby Jet. Jet mining was active during the second half of the nineteenth century for manufacture of personal and small domestic ornaments. Its high lustre on polishing, light weight, intense blackness, and fine texture allowed it to be intricately carved. Such mining was concentrated between Ravenscar and Boulby on the coast, and inland as far as the escarpment at Roseberry Topping. The product of the South American Monkey Puzzle tree, which had been waterlogged and been in the area for some 150 million years, became very popular after Queen Victoria went into mourning following the death of the Prince Consort and always wore a brooch made of jet. Around 1870, some 1,400 Whitby men were employed in jet production and the jewellery was worn by rich and poor alike. Although the trade declined at the start of the twentieth century, production continued and there is still a demand for it. (R. Carpenter)

View of Sandsend & Bay

A view of Sandsend, showing the viaduct and station just north. Before reaching Sandsend, there was another viaduct at East Row, at the line's lowest point. East Row viaduct was only 30 feet above the beach. East Row viaduct was 528 feet long and made up of five 60 foot spans and one of 57 feet 6 inches. Due to its proximity to the sea, this viaduct suffered badly from corrosion and it was decided to replace the original lattice girders with prefabricated steel girders, the job being completed in October 1905. Sandsend viaduct itself was 268 feet long, the shortest of all, and consisted of eight spans of varying length between 27 feet 6 inches and 36 feet, along with two stone spans at either end. The viaduct not only crossed the beck flowing below, but also the foot of Lythe Bank. This view of Sandsend is looking towards Whitby and appears to show a town growing for tourism brought in by the railway above. (LOSA)

A late nineteenth-century view of Sandsend station, just south of the viaduct. The railway between East Rowand Sandsend station was built on a shelf on the hillside above the local houses giving a view of the sea. After leaving Sandsend station and heading towards Staithes, old alum workings left a spoiled headland. Between Sandsend and Kettleness, the original line was planned to run on a shelf above the cliffs. However, while work was suspended, some of the cliff fell into the sea and the NER decided to build two tunnels and avoid these sections. Sandsend Tunnel was 1,625 yards long and Kettleness Tunnel was 308 yards long. (LOSA)

The substantial building at Kettleness station, with signal box on the platform, a favourite site for such boxes on this line, seen from a departing train on 30 April 1958. (R. Carpenter)

LNER Class H1 4–4–4T No. 1327 is seen leaving the northern portal of Kettleness Tunnel with a Middlesborough train in the early 1930s. (R. Carpenter)

After leaving Kettleness, the line passed through Hinderwll before arriving at Staithes station, seen here in NER days with what appears to be a BTP 0–4–4T at the head of a train for Whitby. (WSA)

BR Standard Class 4 2–6–4T No. 80116 is arriving at Staithes station with a train from Whitby on 30 April 1958, this being the last week of operation on the line, it closing five days later. (R. Carpenter)

Departing from Staithes, the same train crosses the viaduct as it heads towards Loftus and Saltburn. (R. Carpenter)

75

The access road and station frontage at Staithes as it appeared only a week before closure, on 30 April 1958. (R. Carpenter)

Staithes viaduct as seen from the station approach road on the same day. Staithes viaduct was the largest of the structures on the line, being 790 feet long and 152 feet high. It was made up of six 60 ft spans and eleven of 30 ft. The viaduct had almost been completed in the first phase of construction, between 1871 and 1874. When the NER took control of construction from July 1875 work continued, but following collapse of the Tay Bridge the railway company was advised that a stronger structure was required in July 1881. Thus, two rows of longitudinal bracing were added and all the other viaducts were fitted with wheel guards at the same time to prevent trains falling off the viaducts if they were blown off the tracks. (R. Carpenter)

After the Second World War, the advent of holidays with pay and the post-War economic 'boom', as reconstruction was underway, brought a growth in railway tourist traffic as the British population sought some fun and an escape from the dreary world of austerity and rationing as the nation struggled to pay off its war debt and the slogan 'export or die' was firmly uppermost in government minds. The newly elected Labour government pursued its policy of nationalisation of essential industries, including the railways, road transport, coal, and utilities, as well as creating the National Health Service – all by 1948. The railways, however, suffered from a lack of investment due the majority of its structures not being too badly affected by bombing, although neglect of maintenance during the war years had left it in a poor state and substantial investment was required. The economic 'boom', however, masked many of the railway's problems as passengers sought escape to the seaside and lines such as this drew substantial traffic during the summer months and the Whitby–Saltburn–Middlesbrough line saw intensive summer services, particularly during the weekends. In 1950, there were fourteen summer Saturday trains, usually of five coaches, and six trains on Sundays but winter services were down to three trains of two or three coaches on weekdays only. By 1958, BR was able to claim that some £58,000 worth of maintenance was needed, mostly on the viaducts, for a line that was only fully used on a dozen summer Saturdays. These summer services did not materialise that year as closure came on 5 May 1958. Only Whitby West Cliff station remained open to serve trains from Scarborough, this lasting another three years. Demolition commenced the following year with the viaducts being dismantled and sold for scrap. The concrete in the viaducts was used for sea defences. The station buildings at Whitby West Cliff, Sandsend, Kettleness, and Staithes survive. This picture of 80116 in the distance after leaving Staithes becomes poignant as it represents one of the last trains on the line as it heads towards Saltburn on 30 April 1958. (R. Carpenter)

RAILWAY STATION, SCALBY.

Scalby station as it appeared at the beginning of the twentieth century, with a train approaching which appears to be headed by a BTP 0–4–4T engine. The Scarborough–Whitby line, Scalby being the first station from Scarborough, began behind the signal box at Falsgrave and entered the Falsgrave tunnel (around 260 yds long) before passing the excursion sidings and then on over a viaduct above Scalby Cut before entering the station. Originally, a cast iron viaduct of seven 30 foot spans stood on the site but after the Tay Bridge disaster it was considered to be too flimsy and was demolished to be replaced by a four arch brick built structure in 1883 and was constructed by the new contractors for the line, John Waddell and Sons at a cost of £4,188. The station yard began immediately at the north end of the viaduct, the points allowing entry being partly on the viaduct. The whole station was in a cramped area between Scalby Cut and Station Road, the latter crossing the line via the picturesque ivy clad bridge shown with the train passing under. Scalby station closed rather early, in February 1953, some twelve years before the rest of the line and the buildings and bridge were demolished in 1974 to make way for a new housing estate. (Author's collection)

A view of the main building at Scalby station, with the goods yard behind. A quarry in the area, which provided rock for breakwaters and piers provided traffic for the goods yard. While proposals were in hand for the Scarborough–Whitby line, a plan was made to bring a branch from Scalby to West Ayton through Forge Valley. This scheme was promoted by a separate company, The Forge Valley Railway Company, who engaged one Eugenius Birch (who went on to become famous as the designer of seaside piers) as engineer. A Bill was prepared for the 1872-3 parliamentary session to acquire the necessary land and build the line, but it had to be withdrawn in March 1873 due in part to objections by local landowner, Lord Londesborough. The proposed line would have been a little over five miles long, starting in a field at West Ayton on the north side of the Scarborough–Pickering road, at the parish boundary. The line would then have crossed the field at the junction of Pickering Road and Cockrah Road, then on a slight falling gradient to pass under two minor roads, then on a curve below Ayton Castle to run along the Forge Valley on the west bank of the River Derwent. At the north end of Forge Valley, the line would have turned east to run on the south bank of the sea cut, the Hackness Road crossing the line via a bridge.

Near to Scalby Road, the Hackness Road was to cross the line by another bridge. The line would have then crossed the Whitby Road, near Newby Bridge, on a fifteen foot high bridge with a twenty-foot span. The Whitby Road would have been lowered by four feet to allow for this. East of the main road, the line would have taken a curve to join the Scarborough–Whitby line and would have formed a junction to allow trains to run direct from Scarborough to West Ayton. The line was never built and the scheme simply faded away. (LOSA)

Cloughton station as it appeared in NER days. The station here often won prizes for its gardens, the Stationmaster being a very keen gardener. Shortly after the line opened, a daily goods train ran from Whitby to Scarborough and return, calling only at the more important stations. From 1892, this was reduced to three days a week and later to only once a week. During the 1930s this goods train ran at night during the summer months to avoid heavy passenger traffic. The goods yard at Cloughton station was kept very busy with large quantities of coal arriving here, the stationmaster having built up one of the largest coal retail businesses in the region. The wagons did not leave the station empty either, pit props (from nearby Duchy of Lancaster Sawmills) were sent from Cloughton to the collieries. (LOSA)

A 1922 timetable for Scarborough–Whitby–Saltburn trains. Opening of this line made a connection with the Whitby West Cliff–Saltburn line and created a through route to Saltburn and Middlesbrough. (Author's collection)

Hayburn Wyke station showing the simple wooden buildings of this small station. The station was originally built on the other side of the line and constructed entirely of timber. It had a steep slope behind the platform and was supported on stilts. This did not meet with the approval of the NER, who insisted that the station was only of a temporary nature and should be a more substantial structure. In 1893, a new platform was built on the opposite side of the track and simply transferred the original wooden buildings over from the other platform. (LOSA)

The area had been a popular tourist attraction well before the railway arrived, the nearby hotel of the same name being fully aware of this. Once the line was established, the Hayburn Wyke Hotel began an aggressive advertising campaign and had posters printed, an example of which is seen here. Indeed, the NER ran charabancs to the area as well as its trains, such was the popularity of the place. (Author's collection)

Not only did the hotel use posters, it also published timetables for trains to Hayburn Wyke from Scarborough in local papers. This one is from the *Filey News* of 1927. (Author's collection)

Another view of Hayburn Wyke station from the opposite end with wooden buildings in view. Official opening of the line took place on 15 July 1885 when the directors of the NER, who were to operate the line, provided a train for use of the directors of the S&WR so that they and the dignitaries of Scarborough and Whitby could travel over the new line. The train left Scarborough at 11.23 with no ceremony, but workmen and the public cheered loudly as the train passed Scalby station, the train making short stops at each station and arrived at Whitby West Cliff at 12.45. A lunch was provided at the Crown Hotel, Whitby and the return train left at 1.45 pm. The journey took an hour and 200 guests banqueted at the Royal Hotel, Scarborough that evening. The line was opened to the public the following day and large numbers of people took a ride over the line, most going to Robin Hoods Bay, extra trains having to be provided so great was the traffic that day. (LOSA)

Stainton Dale station, one of the largest on the line, was only a mile from Hayburn Wyke. The gradient through the station at the end was so steep that a set of catch points had to be installed to prevent detached vehicles running all the way back to Cloughton. In 1899, a driver ran the tender of his engine off the rails at the catch point and was fined 2s 6d for his trouble. First timetable for services from 16 to 31 July 1885 was as follows:

Scarborough	–	9.10 am, 1.00 pm, 5.00 pm, 8.15 pm
Scalby	–	9.18 am, 1.08 pm, 5.08 pm, 8.23 pm
Cloughton	–	9.24 am, 1.14 pm, 5.14 pm, 8.29 pm
Hayburn Wyke	–	9.30 am, 1.20 pm, 5.20 pm, 8.35 pm
Staintondale	–	9.35 pm, 1.25 pm, 5.25 pm, 8.40 pm
Peak*	–	9.43 am, 1.33 pm, 5.33 pm, 8.48 pm
Fyling Hall	–	9.53 am, 1.43 pm, 5.43 pm, 8.58 pm
Robin Hoods Bay	–	9.58 am, 1.48 pm, 5.48 pm, 9.03 pm
Hawkser	–	10.10 am, 1.58 pm, 5.58 pm, 9.13 pm
Whitby West Cliff	–	10.20 am, 2.10 pm, 6.10 pm, 9.25 pm

*Peak was later remamed Ravenscar

[continued opposite]

The northern portal of the tunnel at Ravenscar in the 1930s. (R. Carpenter)

Whitby West Cliff	–	7.40 am, 11.35 am, 3.10 pm, 6.45 pm
Hawkser	–	7.51 am, 11.46 am, 3.21 pm, 6.56 pm
Robin Hoods Bay	–	8.02 am, 11.57 am, 3.32 pm, 7.07 pm
Fyling Hall	–	8.09 am, 12.04 pm, 3.39 pm, 7.14 pm
Peak*	–	8.19 am, 12.14 pm, 3.49 pm, 7.24 pm
Staintondale	–	8.26 am, 12.21 pm, 3.56 pm, 7.31 pm
Hayburn Wyke	–	8.31 am, 12.26 pm, 4.01 pm, 7.36 pm
Cloughton	–	8.37 am, 12.32 pm, 4.07 pm, 7.42 pm
Scalby	–	8.43 am, 12.38 pm, 4.13 pm, 7.48 pm
Scarborough	–	8.50 am, 12.45 pm, 4.20 pm, 7.55 pm

*Peak later renamed Ravenscar

From Stainton Dale, the line then passed through Ravenscar and the small halt of Fyling Hall before entering Robin Hoods Bay. (LOSA)

The largest and most important station on the line was at Robin Hoods Bay, a major tourist attraction with its steep fall down to the village. Here, the plan shows how large the station was. Like many of the stations in the area, there was even a Camping Coach parked here. These were introduced by the LNER in the 1930s and offered cheap holidays. (Author's collection)

A 1936 LNER poster advertising Robin Hoods Bay and shows the village falling towards the sea. (Author's collection)

Class A8 4-6-2T No. 1526 is at Robin Hoods Bay station during the 1930s with a train for Scarborough. During the winter months, the Scarborough–Whitby service was often worked by Sentinel steam railcar No. 2281 *Old John Bull* or Armstrong-Whitworth diesel–electric car *Tyneside Venturer*. Robin Hoods Bay station was popular with station staff as well as visitors and in the eighty years that it was open, there were only five stationmasters, two of whom served there for 55 years. After leaving Robin Hoods Bay, the line passed through Hawkser station before arriving at Whitby West Cliff and then on to Saltburn or Middlesbrough.

The line here and the Malton–Pickering line both closed on 5 March 1963 and left Whitby isolated from the main York–Scarborough line. It seems inconceivable that there should be no rail link between Whitby and Scarborough. Retention of the line between Malton, Pickering, and Grosmont (connecting with the Middlesbrough–Whitby Esk Valley line) would have allowed a direct service from York to Whitby, and given a route from Scarborough, and not left the market town of Pickering disconnected from the main line. Continued existence of a rail route through Pickering may have gone some way in relieving considerable traffic congestion throughout the year. However, it would have meant that the preserved North Yorkshire Moors Railway would not have come into existence, but such investment could have been transferred to the Scarborough–Whitby line which, itself, ran through some spectacular scenery. Following closure, enquiries were made to preserve the coast line but nothing came of it. The line would have continued a connection with Robin Hoods Bay, which is still a popular destination, and brought preserved steam locomotives as yet another attraction to the town. It could be argued that a preserved coast line would have been as good, if not better than the NYMR, because steam trains would have started and terminated at the very popular resorts of Scarborough and Whitby, calling at Robin Hoods Bay, and may well have contributed to reducing severe summer traffic congestion at both seaside towns as good rail connections would have been maintained, and there may have been reduced road traffic across the North Yorkshire Moors National Park. (Bernard Unsworth Collection)

THREE

RURAL BRANCHES

The rural branches in the area were centred around Pickering, which made the little market town quite an important rural junction.

First of these rural lines ran between Pilmoor and Malton, initially avoiding Pickering, and was opened in 1853 (becoming part of the NER in 1854). The line ran from a north-east curve at Pilmoor for 23 miles to Scarborough Road Junction, where it joined the Malton and Driffield Junction Railway whose line gave access to Malton. Both lines opened on 19 May 1853 with stations at Husthwaite Gate, Coxwold, Ampleforth, Gilling, Hovingham (Spa being added in 1896), Slingsby, Barton-le-Street, and Amotherby. Gilling became a junction with the opening of the Gilling–Pickering line in 1875.

The line between Gilling and Pickering was originally part of a scheme to serve Helmsley and Kirkbymoorside in 1845. This line was never actually built, nor was a similar proposal, the Ryedale Railway, of 1862. Its proposed route was to link the two towns to Pickering and the Thirsk–Malton line, similar to that finally built by the NER. Indeed, the NER's original Act of 1866 for the branch was designed to oppose a rival scheme through Helmsley which would have linked Leeds to Teesside. Once the rival proposal had been defeated, the NER only built its line slowly, even trying to abandon the project in 1868.

By 1871, the southern curve at Pilmoor and the new branch as far as Helmsley had been opened, extending to Kirkbymoorside (the NER naming the station Kirbymoorside) in 1874, the remainder of the line through to Pickering being completed in 1875. Stations were also provided at Nunnington, Newton, and Sinnington. Initial services went as far as Gilling to link with Thirsk and Malton trains. Gradually, trains ran through to York, via Pilmoor South Curve to Bishophouse Junction, replacing Malton–Thirsk services by 1914. With the predominance of the Pickering–Gilling line, the Gilling–Malton route lost its important role and began to fade. By 1895, only four trains between Pilmoor and Malton were running and, by 1923, the line became a feeder for York–Pickering trains, even these services had disappeared by 30 December 1930, the line's only traffic being through summer holiday trains to Scarborough.

The final branch to Pickering was from Seamer, where it left the main York–Scarborough line, and could provide a roundabout route, via Pickering and Grosmont,

to Whitby. The line was built and opened by the NER in 1882, following an earlier proposal for a Forge Valley Railway which would have used the narrow valley north from East and West Ayton. It was planned to link with the Scarborough–Whitby line and actually had a Bill before parliament in 1873, but it was later withdrawn.

The Forge Valley line itself ran for sixteen-and-a-half miles and was single track from Seamer Junction to just south of Pickering, where it joined the line from Rillington for access to the market town. There were stations at Forge Valley (which served East and West Ayton), Wykeham, Sawdon, Snainton, Ebberston (Wilton until 1903) and Thornton Dale. The line served a farming community and all stations, except Wykeham, had facilities to deal with livestock and agricultural produce, which provided most of the freight traffic for the line. There was, also, a limestone quarry at Thornton-le-Dale which provided extra freight traffic.

With completion of the Forge Valley line, the rural branch network around Pickering was complete and served the community for several years.

Jurassic limestone, which covers an area of around 2,700 sq km around the Vale of Pickering, Hackness, and Flamborough and south as far as Market Weighton provided quarrying opportunities and, along with sandstone in the Staithes area and shales around Whitby, provided much freight traffic for the railway companies over the years. Here, limestone is at the crushing plant of Hargreaves quarry at Pickering, much of which will leave the area by rail. (Beck Isle Museum, Pickering)

Along with the main lines, quarrying companies built their own railway systems to transfer stone from the quarry face to railheads for trans-shipment elsewhere. An example of such a railway can be seen in this view of the railway at Hargreaves quarry with Jack Marshall driving a loco with a train of limestone from the quarry face. (Beck Isle Museum, Pickering)

Approaching Malton from Driffield is the little station at Settrington, seen here in NER days. This line joined the route from Pilmoor and gave access to the main line to York, offering a through route from York to Driffield and Thirsk. This line opened in 1853, becoming part of the NER a year later. (LOSA)

A timetable for train services along the Malton–Driffield branch in 1922. (Author's collection)

A view of Barton–le–Street station, on the Pilmoor–Gilling line in NER days with a train of limestone being shunted out of the yard. The line here had only a poor passenger service to Malton. Indeed, trains to Thirsk had ended by 1914, and some nine years later, the line only acted as a feeder for York services from Pickering and even these had finished on 30 December 1930. (LOSA)

Slingsby station in NER days. Although local services were poor, the LNER used the line to bypass busy York on summer Saturdays. Two trains ran in each direction, despite the need for a double reversal at Malton, which was achieved by the Malton pilot engine pulling the train with its loco. at the other end between Scarborough Road Junction and Malton station. In BR days, during the summer of 1959 there were four scheduled workings over the route to and from Scarborough. (LOSA)

Hovingham station towards the end of the nineteenth century, the 'Spa' not been added to the station name until 1896. This quiet little backwater appears to have some freight work, probably just local traffic. The summer holiday trains ceased over this line after 1962 because an accident on the northbound junction with the York main line forced closure and it never reopened. Therefore, the Thirsk–Malton service ceased and only goods traffic survived on the line until 7 August 1964, except for the three-and-a-half miles at Malton, these finishing ten weeks later. (LOSA)

Gilling Junction station after opening of the line to Pickering, via Helmsley. Trains from Malton and Pickering met here but the line from Pickering became the more important, not least because it served the market towns at Helmsley and Kirkbymoorside as well as Pickering itself. (LOSA)

YORK, PILMOOR, GILLING, MALTON, and PICKERING.—North Eastern.

Miles	Down.	Week Days only.					Miles	Up.	Week Days only.					
		mrn	mrn	mrn	aft	aft			mrn		k	aft	aft	
	York........dep.	7 48	1015	3 10	5 17		Pickering........dep.	7 15	9 57	3 55	5 51	
5¼	Beningbrough........	1025	3 20	5 27	4	Sinnington........	7 24	10 7	4	6 0	
9¾	Tollerton........	1033	3 28	5 35	7	Kirby Moorside......	7 34	10 14	4 11	6 8	
11¼	Alne 772........	8 5	1037	3 32	5 40	9¼	Nawton........	7 40	10 20	4 17	6 14	
13¼	Raskelf........	8 10	1042	3 37	5 45	12¼	Helmsley........ {arr. dep.}	7 45 7 50	10 25 10 26	4 22 4 25	6 19 6 21	
14	Pilmoor 753........arr.	5 51								
—	731 Newcastle ‡..dep.	5 16	735	10b15	4 0	15¾	Nunnington........	7 57	10 33	4 32	6 28
—	731 Darlington †.. "	6b28	9 13	12 18	4 25	18¾	Gilling *........arr.	8 4	10 39	4 38	6 34
—	731 Thirsk "	7 22	10 23	1 6 6	5 11	—	Mls Malton......dep.	7 25	9 57	3 20	5 54
—	Pilmoor........dep.	5 58	—	4½ Amotherby........	7 39	10 11	3 34	6 8
18¾	Husthwaite Gate......	8 20	1052	3 47	6 7	—	6 Barton-le-Street......	7 43	10 15	3 38	6 12
20¼	Coxwold........	8 30	11 0	3 53	6 12	—	7¾ Slingsby........	7 48	10 20	3 43	6 17
22¾	Ampleforth........	8 36	11 6	3 59	6 18	—	9¼ Hovingham Spa....	7 53	10 25	3 48	6 22
25¼	Gilling *........arr.	8 41	1111	4 4	6 23	—	13 Gilling *........arr.	8 0	10 32	3 55	6 29
—	Gilling........dep.	8 20	1116	4 15	6 43	—	Gilling........dep.	8 10	10 44	4 41	6 40
28¾	Hovingham Spa......	8 26	1122	4 21	6 49	21½	Ampleforth........	8 16	10 50	4 50	6 46
30½	Slingsby........	8 31	1127	4 26	6 54	23¾	Coxwold........	8 30	11 7	4 56	6 52
32½	Barton-le-Street......	8 35	1131	4 30	6 58	25¼	Husthwaite Gate......	8 34	11 12	5 0	6 56
34	Amotherby........	8 39	1135	4 34	7 2	30	Pilmoor 728, 753...arr.	5 16
38½	Malton 758, 759 arr.	8 52	1148	4 47	7 15	36¾	728 Thirsk........arr.	9 20	1247	6 7	7 42
—	Gilling........dep.	8 48	1115	4 10	6 36	58½	728 Darlington †.. "	10 b 8	13 39	7	8 b 40
28¾	Nunnington........	8 54	1121	4 16	6 42	94½	728 Newcastle ‡.. "	11 37	2 b 53	8 26	10 5
31¼	Helmsley........ {arr. dep.}	9 0 9 1	1127 1130	4 22 4 24	6 48 6 49	—	Pilmoor........dep.	5 34
34¼	Nawton........	9 7	1136	4 30	6 55	30¼	Raskelf........	8 43	5 40	7 6
37	Kirby Moorside......	9 14	1144	4 36	7 1	32¼	Alne 772........	8 49	11 21	5 46	7 11
40	Sinnington........below	9 20	1151	4 42	7 7	34½	Tollerton........	8 53	a	6 0	7 17
44	Pickering 750, arr.	9 28	12 0	4 50	7 15	38¾	Beningbrough... 766	9 1	a	6 8	7 23
								44	York § 338, 763, arr.	9 14	11 47	6 18	7 35

a Stops when required to set down from beyond Alne
b Change at Raskelf.
d Change at Alne.
k Passengers for Pilmoor and the North change at Alne.
l Saturdays only, changing at Raskelf.
* Station for Ampleforth College.
† Bank Top Station.
‡ Central Station.
§ 1¼ miles to York (Layerthorpe) Sta., Derwent Valley.

☞ **For other Trains**

BETWEEN	PAGE
York and Pilmoor	728
York and Pickering	759

A 1922 timetable for trains operating over both the Malton and Pickering branches. (Author's collection)

The imposing station at Helmsley, giving an indication of the importance of this market town, its castle being a tourist attraction for many years, no doubt bringing rail passengers during the summer. The town also had grit quarries nearby, providing freight traffic for the NER, the old workings being used by 'courting couples', giving some privacy for them. The town also saw summer trains taking local children to Scarborough in the 1950s. (LOSA)

Kirkbymoorside station (named Kirbymoorside by the NER) as it appeared in the early twentieth century, with a Fletcher BTP 0-4-4T, supplied by Malton shed, at the head of a train for Gilling. In the background, a saddle tank loco shunts in the yard. (LOSA)

Another view of 'Kirbymoorside' station at the end of the nineteenth century. Over time, the line from Pickering became the most dominant with trains to York replacing those on the Malton line by 1914. These were usually two to four trains a day each way on weekdays, right up to closure on 31 January 1953. The last of these trains was the 6 pm York–Pickering service, hauled by D49 'Shire' Class 4-4-0 No. 62735 *Westmorland*. (LOSA)

Last station on the branch to Pickering before approaching Mill Lane Junction for access to Pickering was at Sinnington with a train approaching to collect quite a number of passengers on the platform. As most appear to be in their 'Sunday best', this could be an excursion to Scarborough. After cessation of the York services, the only passenger trains operating over the branch were 'Ramblers' specials to Kirkbymoorside from West Yorkshire. Special trains also ran from Helmsley to places like London, Kings Lynn, and Largs, as well as the Sunday school outings to Scarborough. The last of these ran on 27 July 1964, the line itself closing only two weeks later.

Evidence that the line once did exist are that some old station buildings have found another use. Here, the old Kirkbymoorside station can be seen in 2007 with the old platform kerbs visible and the trackbed filled in. The old bay window of the main station building has remained, although an extension has been added to part of the frontage. (Louise Ferguson)

Another view of old Kirkbymoorside station, showing the other end of the main building. The goods shed beyond is now a tractor sales showroom. (Louise Ferguson)

Forge Valley Station.

The station at Forge Valley (which served the twin villages of East and West Ayton) at the end of the nineteenth century with passengers boarding a local train. While proposals were in hand to build the previously mentioned line to Scalby, the NER had completed its line from Gilling to Helmsley in 1872 and arrived at Pickering in 1875. Thus, an extension from Pickering to Scarborough would provide an alternative route to York, as well as serving the fertile farming areas in Ryedale. In 1873, the NER proposed a line between Pickering and Seamer, where it would meet the Scarborough–York main line. Ironically, a Seamer station on the Forge Valley branch would actually have been closer to the village than that which exists on the main line. The NER was in no hurry to build the new line and construction took two-and-a-half years, actually opening to regular passenger and goods traffic on 1 May 1882. First trains on the new line were excursions run between Scarborough and Pickering on 24 April. The new line ran parallel with the Scarborough–York line as far as Rillington and local passengers could now take a train along the branch instead of travelling some two miles to join trains on the main line. The name 'Forge Valley' for the first station was used to avoid confusion with Great Ayton, although the line never actually ran through Forge Valley itself. (LOSA)

A further view of Forge Valley station in NER days. Regular passenger services along the Forge Valley line began with four trains each way a day, except Sundays when there was no service, increasing to five a day prior to the First World War, supplemented by additional trains between Scarborough and Forge Valley in the summer months. Fares from Scarborough to Forge Valley were: 1s (5p) first class, 10d (4p) second class, and 6½d (3p) third class. A late train from Scarborough was provided one day a week, 10.55 pm on Thursdays, running through to Pickering. Later, the train ran from Scarborough on Saturdays at 11.05 pm only as far as Forge Valley. This late train even ran during wartime. No Sunday service was ever run over the line. Following the end of the First World War, passenger services decreased to four a day each way, with three extra trains running during the summer months. One of these trains ran through to Gilling to serve Ampleforth College and required a reversal at Pickering. Outbreak of war again in 1939 reduced passenger services to three trains a day, the last being the 5.20 pm from Pickering, with the return from Scarborough at 6.30 pm. This remained the pattern until the end of passenger services in 1950. (LOSA)

After crossing the main road and traversing an embankment, before crossing the main road again, the line entered Wykeham station, seen here in the early twentieth century with several enamel adverts for such things as 'Lipton's Tea'. Along with regular passenger services, excursion trains often ran over the branch. One regular excursion was the Scarborough Sunday school outing, which occurred every Whit Monday. In June 1903, some 1,030 adults and 2,850 children left Scarborough Station for Cloughton, Forge Valley, Ganton, Thornton Dale, Sawdon, and Wykeham. Some 50 adults and 200 children from Manor Road Congregational Church, Scarborough travelled to Forge Valley, the return fare being 11*d* (4½p) for adults and 3½*d* (1½p) for children. Other excursion traffic was generated by the annual agricultural show at Ayton, trains being run between Forge Valley and Pickering, along with trains from Scarborough to Forge Valley. Horse–Box special trains ran to Forge Valley from Hull, Malton, and Helmsley. On show days, the last train to Scarborough left Forge Valley station at 10.45 pm. (LOSA)

Next station along the line was at Sawdon, which served nearby Brompton whose claim to fame is that it is the original home of aviation. When opened, traffic over the line became quite heavy and in the years between 1900 and 1914, Forge Valley station alone issued an average of 20,000 tickets a year to passengers, which brought in an income of around £750. Along with passengers, there was, also, much freight traffic. Each year, Forge Valley station handled around 1,000 head of cattle, 1,500 tons of coal were unloaded, 2,500 tons of goods were received and 1,000 tons sent out, bringing in an income of around £1,500 a year. The majority of stations along the line, not least Snainton, which served the largest town, would have seen similar figures in the pre-First World War years. The two world wars and increasing road competition brought substantial decline in both freight and passenger traffic, the 'Great Depression' having a devastating effect on such traffic during the 1930s and the branch becoming increasingly uneconomic. (LOSA)

Exterior of Snainton station in NER days. This station was the most important on the line, reflecting the fact that it served the largest village. It was a passing place and had two platforms. Extensive sidings were also provided here due, no doubt, to its role as the manufacturer of bricks used in the construction of the line and its stations. (LOSA)

Snainton station with a local train approaching, possibly hauled by a Fletcher BTP 0–4–4T or Wordsell Class o 0–4–4T. Motive power on the Forge Valley branch would also have included Wordsell F8 2–4–2Ts. In 1928, the branch was the first in the area to have a regular Sentinel steam railcar service. A memo to the LNER Traffic and Locomotive Committee of 23 March 1926 discussed ordering two new railcars, following successful trials with the first two obtained, one of which was to be operated between Scarborough and Pickering. In the end, one of these new railcars went to Hull while the other went to Heaton. In December 1928, car No. 2136 *Hope* was based at Pickering for use on the Forge Valley line and a railcar service would operate over the branch for the next twenty years, although they often proved to be unreliable and struggled to cope with any vehicles which were attached to them. When the railcars were withdrawn, passenger trains operating over the branch were push–pull fitted with, usually, a G5 0–4–4T providing motive power. (LOSA)

Following Snainton, the next station along the line was Ebberston, initially Wilton station until 1903, serving both Wilton and Ebberston villages. Buildings on the line were described in a local paper of the day as 'of a uniform plan. Waiting rooms, booking offices, and other apartments are commodious and well fitted up, and in front is a glass covered verandah. The platforms are upwards of four hundred feet in length.' For such a small branch, these were handsome buildings indeed. (LOSA)

A late nineteenth-century view of the main station building at Ebberston station. Following nationalisation of the railways in 1948, the Forge Valley branch was in terminal decline and closure became inevitable, only three trains a day were running and the line was little used. Thus, on 3 June 1950, the last train left Scarborough for Pickering. Ex-LNER G5 0-4-4T No. 67273 propelled its two coach train out of Scarborough Central station with Driver Douthwaite of Malton shed in the leading coach and Fireman Nelson on the loco. Fog signals were exploded at some of the intermediate stations. One passenger, then 81 years old, had actually ridden on the first train 68 years earlier. Following closure, the railway bridge at East Ayton, which crossed the River Derwent, was cut up on site and the bridge over the A170 road between West Ayton and Wykeham was demolished. Forge Valley station was, ironically, taken over by North Riding County Council and used by the Highways Department, with further buildings being added. The stationmaster's house and goods shed remained intact. (LOSA)

Last station on the branch before Pickering was at Thornton Dale, its handsome building seen here not long after opening with its station staff. The station served the local tourist attraction of the nearby village of Thornton-Le-Dale, still a popular attraction today. It also had Slater's limestone quarry nearby which provided much freight traffic for the station. Indeed, so important was this traffic it was enough to keep the section of line between Thornton Dale and Pickering open until 1964, the remainder of the railway system around Pickering suffering closure the following year. (LOSA)

A section of the disused embankment of the railway between West Ayton and Wykeham. A tunnel which took a lane under the railway is visible about halfway along. The picture was taken early in 2007. There is further evidence that the line once existed. Part of a railway cutting remains between Seamer station and Forge Valley and passes under a bridge which carries the road into Seamer village itself, the location would have provided an ideal site for a local station here to serve the growing village. All of the former station buildings remain in private use. Ebberston station building being fully restored in 1998 and three ex-BR coaches have been converted to provide holiday accommodation, a reminder of the pre-War years of Camping Coaches, one of which was in the station yard at Forge Valley station, along with others, in the 1930s. In those days, six people could stay for a week a cost of £2 10s (£2.50). Cutlery, crockery, bedding, etc. were all provided, but holidaymakers were expected to provide their own food and paraffin for lighting and heating. The only proviso was that visitors using these Camping Coaches had to travel by rail from their home town to their final destination, a useful source of revenue during the depression years of the 1930s. These coaches were scattered all over the NER system and proved popular for cheap holidays. An example of a Camping Coach can be seen at neaby Levisham station on the preserved North Yorkshire Moors Railway. (Author's collection)

FOUR

THE SEAMER–BRIDLINGTON BRANCH

While construction of the Y&NMR main line between York and Scarborough was ongoing, plans were underway to link Hull with the seaside resort, via Bridlington. The section between Hull and Bridlington was proposed by the Hull and Selby Railway, while the section between a junction with the main York–Scarborough line at Seamer and Bridlington was proposed by the Y&NMR itself, both lines to meet head-on at Bridlington. The section between Seamer und Bridlington was authorised under the 'York and North Midland Railway (Bridlington Branch) Act' on 30 June 1845, permission also being given to raise a capitol of £87,000 (50% of which could be obtained through a share issue). A further maximum borrowing of £29,000 was also authorised, with allowance for further borrowing if existing loans had been paid off.

The line was built relatively quickly, the section between Seamer and Filey being opened on 5 October 1846 (the section between Bridlington and Hull opening the following day). Opening of the Seamer–Filey section was celebrated in Filey, with visitors from Scarborough and surrounding villages enjoying events organised by Henry Bentley. A collection, which totalled £37, was made in Filey for entertainment of the poor to coincide with opening of the line. A meal for 400 schoolchildren and 70 of the town's poor was provided at the Royal Hotel, all to coincide with the arrival of the railway company's directors at 1.00 pm. To conclude these celebrations, there was a fireworks display that evening. The thirteen-and-a-half mile section between Filey and Bridlington would take a little over a year longer to complete due to slightly more difficult terrain through which the line passes und was opened on 20 October 1847.

Traffic in the early years was mostly agricultural and there were few passenger trains. Indeed, by 1910, there were only six through trains between Hull and Scarborough, most stopping at all stations and taking two-and-a-half hours for the 53¾ miles. During the summer months as the years progressed, scheduled services were supplemented by excursion and holiday trains as tourism developed in the area.

In the late nineteenth century, there was a growth in fish traffic. At its peak, 160 fish wagons a week left Filey, with fish bait from The Wash also coming in by rail. Fish caught by Filey fishermen was checked in by the Filey Stationmaster and loaded

into boxes. These boxes were then loaded into vans at the fish dock sidings, on the opposite side to the goods yard, and loads were sent three to four times a week, one train even going as far as Kings Cross. Plans had been mooted for a fishing harbour at Filey, but too many objections were made and the idea was abandoned. The result was that Filey fishermen went to Scarborough and Grimsby by train on Mondays and returned home on Fridays, these possibly being the first railway commuters in the area.

Opening of the line between Seamer and Bridlington allowed development of towns and villages along its route, particularly as seaside tourism grew. Filey, in particular, benefited greatly from this new industry brought about by the coming of the railway.

An LNER advertisement for Filey in the 1920s. It was advertisements such as these which brought families flocking to the seaside. (Filey Town Council)

First station on the Bridlington branch from Seamer was at Cayton, seen here in the mid 1940s and just before the LNER had ceased to exist. The small timber structures on the platform suggest that the station was not greatly important and this was borne out after nationalisation when the new North Eastern Region of BR decided to close Cayton station to passengers in 1952. (H. Metcalfe)

Another 1940s view of Cayton station with LNER B16 4-6-0 approaching from Seamer. The B16s were originally designed by Sir Vincent Raven for the NER as Class S3 and a total of 53 were built after the First World War. These locos were three-cylinder machines with five foot eight inch driving wheels. Some of these engines were rebuilt by Nigel Gresley as Class B16/2 from 1937. They had new cylinders and two sets of Walschearts valve gear, replacing the Stephenson's motion previously fitted, and used Gresley's derived motion. The running plate was raised above the wheels, a Gresley cab replaced the Darlington design, and outside steam pipes fed the outside cylinders. Seven of these locos were so treated before the outbreak of the Second World War. Edward Thompson rebuilt a further seventeen engines, to Class B16/3, with three sets of Walschearts valve gear instead of using Gresley's derived motion, until April 1949. No further examples were rebuilt due to the availability of new Thompson B1 4-6-0s and K1 2-6-0s. Most of these engines were concentrated at York and Leeds Neville Hill sheds, with the odd example being based at Scarborough in 1935, 1952, and 1959 probably because B16 locos often worked *The Scarborough Flyer* between York and the seaside resort. The Leeds allocated examples could often be found at the head of trains to Filey Camp in the 1950s. (H. Metcalfe)

RAILWAY TIME TABLE.

Trains leave Scarbro' for Hull at

					SUN.
a.m.	a.m.	a.m.	p.m.	p.m.	p.m.
6.40	10.30	11.25	4.30	6.0	3.15

						SUN.
	a.m.	a.m.	a.m.	p.m.	p.m.	p.m.
Filey.....	7.5	10.45	11.48	4.50	6.25	3.40

						SUN.
	a.m.	a.m.	p.m.	p.m.	p.m.	p.m.
Bridlington...	7.52	12.34	5.25	7.12		4.27

								SUN.
	a.m.	a.m.	a.m.	a.m.	p.m.	p.m.	p.m.	p.m.
Beverley...	9.0	9.8	11.54	1.35	5.0	6.16	8.20	5.35

Trains leave Hull for Scarbro' at

						SUN.
a.m.	a.m.	p.m.	p.m.	p.m.	p.m.	p.m.
7.15	10.15	12.20	4.10	4.30	7.10	7.0

							SUN
	a.m.	a.m.	p.m.	p.m.	p.m.	p.m.	p.m.
Beverley...	7.40	10.34	12.45	4.26	4.50	7.34	7.24

							SUN
	a.m.	a.m.	p.m.	p.m.	p.m.	p.m.	p.m.
Bridlington..	8.15	8.46	1.0	1.55	5.19	8.45	8.35

							SUN.
	a.m.	a.m.	p.m.	p.m.	p.m.	p.m.	p.m.
Filey..	8.52	9.23	1.30	2.33	5.48	9.24	9.13

ON TUESDAYS ONLY.

Hull....at 4.20 p.m. and Beverley at 4.44 p.m.

An early timetable published in the *Filey Chronicle* of 31 October 1857 showing services for trains between Scarborough and Hull and showed only the main stations on the line. (Crimlisk-Fisher Archive, Filey)

Before reaching Filey, the next station after Cayton was Gristhorpe, seen here with an NER 4-4-0 at the head of a train for Scarborough. Like Cayton station, Gristhorpe had only a short life in BR ownership, closing to passengers in 1959. Evidence that the station once existed are the remains of the platform, the station building (now in private ownership) and the signal box. (LOSA)

Ex-LNER B16/3 4–6–0 No. 61472 (one of the Thompson rebuilds) of York shed (50A) is seen on the goods yard just before the level crossing takes the railway into Filey station. The signal box and level crossing gates are visible behind the loco.
(H. Metcalfe)

Ex-LMS Class 4 Ivatt 2–6–0 stands at the goods shed, Filey in the early 1960s. The goods shed here was of Y&NMR origin and designed by George Andrews. The shed was constructed of brick with a slate roof on timber trusses. An open extension had a continuation of the slate roof on cast iron columns. A timber platform, with recesses to allow carts to reverse in for loading was inside the shed. A crane was fitted between the roof trusses and platform. The open extension was removed in the late nineteenth century, leaving the shed with a hipped roof at the Hull end and gable roof at the Scarborough end. Two blocks of terraced cottages were built adjacent to the goods shed in around 1866. (Crimlisk-Fisher Archive, Filey)

A view of the goods shed and ex-LMS Class 4 2–6–0 shunting from the station. A crane is now in the yard. The goods shed was demolished in March/April 1969 and the cottages shortly afterwards. The last occupants, Mr. and Mrs. Metcalfe, left in March 1969. The Silver Birches Home now stands on the site. (Crimlisk-Fisher Archive, Filey)

The signal box at Filey station, with stationmaster's house in the background. Just beyond the level crossing is the goods shed and yard and the crossing keeper's cottage can be seen just to the right of the signal box. The level crossing protected Muston Road (then called Mill Lane) and a modern barrier type is still in use to stop traffic when trains are due. The signal box dates back to 1911 following re-signalling in the area between 1906 and 1913. It was of the standard NER type and had a McKenzie and Holland No. 16 frame with 36 levers and one gate wheel. Twenty-eight levers were working and there were eight spare. The frame here also controlled the locking of the three–lever McKenzie and Holland six inch frame installed at the entry to the coal and sheep pen sidings. The crossing keeper's house was of original Y&NMR design. There was also a railway house in the coal yard. (Crimlisk-Fisher Archive, Filey)

An unusual feature at Filey was this NER Crossbar signal at the level crossing in July 1964. It can be seen just beyond the level crossing, to the right of the goods shed in the previous view. The signal, signal box, semaphore signals, and level crossing gates were removed in around 2000. (R. Carpenter)

A plan of Filey station goods yard around 1925, showing the goods shed, fish stage, level crossing and signal box. Two landowners, Elizabeth Westerby and Robert Mitford, had their property bought by the Y&NMR to be used for the goods yard and station at Filey. The original survey for the station complex was made in 1844 by John Birkenshaw, then assistant engineer to Robert Stephenson. The plans were then deposited with the Clerk of the Peace for the North and East Riding of Yorkshire. (Author's collection)

A plan of Filey station around 1925, showing sheep pens and coal drops. (Author's collection)

An LNER poster for Filey, giving an indication of the beach in the 1930s. (Filey Town Council)

The interior of Filey station in the early twentieth century. Like most stations on the Seamer–Bridlington line it was designed by Y&NMR Architect, George Andrews, and comprised of a covered train shed with offices, etc. on the Up side. The two platforms were 276 ft long on the Up side and 277 ft on the Down side. Passengers could leave the station from both platforms, but there were problems collecting tickets on the Down side, so a 480 foot ticket platform was added at the Hull end. It remained in use up until 1900, and was still on LNER plans in 1925, but was removed when full sized timber extensions were added. When the ticket platform was in use, Down trains stopped adjacent to it and Filey passengers had their tickets checked. Trains then drew up to the main platform and passengers alighted. The platforms were extended in 1888 to increase length to 364 ft for the Up side and 383 ft for the Down side. A further extension was added in 1906: 390 feet for the Up side and 405 feet for the Down side. The platforms were two feet six inches high, and twelve feet six inches wide. In NER days both platforms had weighbridges by Pooley and Sons of Liverpool.

The station buildings were of medium brown coloured brick with sandstone features. The main entrance door had a stone surround with stone cappings to all the buildings and stone window sills. All buildings were attached to the train shed, made up of three rectangular structures, two identical ones at the main entrance, on either side of the main entrance building. Inside were the offices and refreshment room (in use on opening day, but closed around 1881). The train shed itself had hipped ends, covered in slates on timber planking laid at an angle to the roof trusses, these being of wrought iron. The roof overhanging edge was finished with decorative carved timber eaves. The train shed was open ended, with valances covering bowstring girders. Timber boarding down to the platforms was added in 1860 to protect passengers from the elements. These can be seen in this view looking towards Scarborough and remained in situ until 1950, when they were completely removed, revealing the shed ends in their original form. (Crimlisk-Fisher Archive, Filey)

Filey Station looking towards Bridlington around 1902. Bunting suggests that there was some sort of celebration underway. Was this to mark the end of the Boer War or the accession to the throne of King Edward VII? Over the years alterations were made to the station. On 14 July 1883, a post box was installed on the left hand side of the station entrance and there were three collections a day with an extra one in the summer. In 1894, plans were drawn up for an extension of the building on the south side to house a new men's toilet. A contract was awarded to Arthur Haxby & Co. for two glass awnings, one over the main entrance and the other over the exit on the Down side. The original lamp on the main doorway was retained and a special ventilated housing was made in the awning to accommodate it. This contract was awarded in 1910 and, at the same time, the Stationmaster reported that the main water supply had been renewed. The main entrance door was widened in June 1913 to give better access for trolleys and barrows and a folding grille-type gate was fitted at the platform entrance. A standard NER footbridge was installed around 1870 and is unusual in that the steps to the Down platform are on the outside of the train shed and protected by a timber and glass housing, passengers entering the down platform through an arched opening in the train shed. In 1900, Filey Council approached the NER if it could purchase the strip of land outside the station entrance to improve the road and plant trees. The NER Engineer, A.G. Stevenson, gave permission and that the price of the land would be 6s (30p) a square yard. The council felt that the price was too high and no further action was taken. (Crimlisk-Fisher Archive, Filey)

On 12 June 1905, NER Wordsell R Class 4–4–0 No. 676 unloads passengers at Filey station on its way to Scarborough during speed trials. Only a few years before, in 1882, proposals were put before parliament to build a harbour at Filey as part of projects for three harbours to be built by convicts at Dover and Peterhead, as well as Filey. The new harbour would have had the Brigg extended, with a fort at the end, then a small opening (presumably to allow entry for fishing boats, the town being the most important for fishing in the north-east of Yorkshire because of its proximity to the Dogger Bank fishing grounds), followed by a pier wall which would have extended round from the Bell Buoy to either opposite Hunmanby Gap or Reighton Sands and would have had another fort at that end. Another fort was then to have been placed on the shore at Reighton Sands. When completed, the harbour would have been large enough to hold up to 20 battleships (threats to national security being perceived as coming from Russia or the newly unified Germany – which would become fact in 1914) as well as fishing boats operating along the east coast between Hull and Whitby. It was also to act as a refuge harbour in times of bad weather in the North Sea. Eventually, only the harbour at Dover was built, the other projects at Peterhead and Filey being abandoned. Had the harbour been built, it did have NER support, then Filey would have become the major fishing centre for the area, possibly to the detriment of Hull and Grimsby. The town would have expanded rapidly to meet the demands of the fishing industry and the Royal Navy, possibly becoming the most important in the area, Scarborough being no more than a small holiday town. The railway station and its layout would have been substantially expanded to cope with freight and passenger demands placed upon it and may well have become the main route to York and London, the line from Seamer to Scarborough no more than a branch used in the holiday season. No doubt, a loco shed would have been placed in Filey to provide motive power for traffic emanating from the new harbour. Indeed, so important may the town have become that this book could have been entitled 'Steam Around Filey'. (Crimlisk–Fisher Archive, Filey)

SCARBOROUGH, FILEY, BRIDLINGTON, DRIFFIELD, and HULL.—North Eastern.

Up. — Week Days.

Miles	Station	mrn	mrn	mrn	mrn	mrn	mrn	mrn	mrn	mrn	mrn	mrn	aft	aft	aft		
	Scarborough ...dep.		6 25					8 22				1025	1117	1 25	2 30		
3	Seamer		6 32										1124	1 32	2 37		
5¼	Cayton		Sig.										1130		2 43		
7¼	Gristhorpe	To Market Weighton, see page 719.	Sig.		Via Enthorpe, see page 719.								1134		2 47		
9¼	Filey { arr.		6 47					8 36				1040	1139	1 41	2 52		
	{ dep.		6 49					8 38				1042	1141	1 43	2 54		
12¾	Hunmanby		6 56					8 44				1049	1148		3 1		
16¼	Speeton		7 6									1059	1158		3 11		
19¼	Bempton		7 12										12 4		3 17		
20¼	Flamborough *		7 15					9 0				11 5	12 7	2 0	3 20		
23	Bridlington { arr.		7 21					9 4				1112	1213	2 7	3 26		
	{ dep.	6 30	7 24		8 5	8 15		9 30	9 8	9 13	1020	1055	1116	1217	1 30	2 12	3 29
25¼	Carnaby		7 29								1025			1222		3 34	
28¼	Burton Agnes	d	7 35							9 22	1031			1228	1 39		3 40
30	Lowthorpe		7 40								1036			1233	1 44		3 45
32¼	Nafferton		7 45								1041			1238	1 49		3 50
34½	Driffield 719, 720 { arr.	6 50	7 50		8 21		8 46			9 32	1046	1111	1134	1243	1 54	2 28	3 55
	{ dep.	6 53	7 52		8 24		8 48			9 34	1048	1113	1138	1246	1 59	2 30	3 57
37½	Hutton Cranswick		7 59								1055			1253			4 4
40½	Lockington		8 6								11 2			1 0			4 11
42½	Arram		8 11								11 7			1 5			4 16
45½	Beverley 712		8 17				9 3			9 49	1113		To Selby, see page 719.	1153	1 11	2 45	4 22
49¼	Cottingham		8 23				9 12			9 58	1122			12 2	1 20	2 55	4 31
53¼	Hull ‡ 724, 728, 792 arr.		8 39		8 55		9 23		9 45	10 8	1133			1213	1 31	3 6	4 42
105¼	724 LEEDS (New) arr.				9 49	1034				12 7			2 22	2 22	3 19	4 41	6 47

Up. — Week Days—Continued. | Sundays.

Station	aft	aft	aft	aft	aft	aft	aft	aft	aft	aft	aft			aft	
Scarborough dep.	3 30				5 17		6 10		8 28					5 0	
Seamer					5 24		6 17		8 35					5 7	
Cayton					5 30		6 23		8 41					5 13	
Gristhorpe				Saturdays only.	5 34		6 27		8 45					5 17	
Filey { arr.	3 44				5 39		6 32		8 50					5 22	
{ dep.	3 46				5 41				8 52					5 24	
Hunmanby	3 52				5 47				8 59					5 31	
Speeton					5 57				9 9					5 41	
Bempton					6 3				9 15					5 47	
Flamborough *					6 6				9 18					5 50	
Bridlington { arr.	4 10				6 13				9 25					5 58	
{ dep.			4 35	5 13	6 17		6 50	7 15	9 29					6 5	
Carnaby		Thursdays only.					6 55		9 34					6 10	
Burton Agnes					6 26				9 40					6 16	
Lowthorpe					6 31				9 45					6 21	
Nafferton	Saturdays only.					7 6			9 50					6 26	
Driffield 719, 720 { arr.			4 51	5 29	6 38		7 11	7 31	9 55					6 31	
{ dep.			4 45	4 53	5 31	6 41		7 13	7 33	9 57					6 35
Hutton Cranswick			4 52		6 48				10 4					6 42	
Lockington			4 59				Sig.		1011					6 49	
Arram		Via Enthorpe.	5 4				Sig.		1016					6 54	
Beverley 712			5 9	5 46	7 0		7 32		1022	To Selby, see page 719.				7 0	
Cottingham			5 19	5 55	7 10		7 41		1031					7 13	
Hull ‡ 724, 728, 792 arr.			5 30	6 6	7 23		7 52		1042					7 25	
724 LEEDS (New) arr.			7 58	6 26			1013	1013						1013	

d Stops when required to take up for beyond Driffield.

* 2½ miles to Flamborough Village, and 3½ miles to Flamborough Lighthouse or the North Landing.
‡ Nearly 1 mile to H. & B. (Cannon Street) Station.

∴ For **OTHER TRAINS** between Scarborough and Seamer, see pages 705 and 715.

A 1910 timetable for train services between Scarborough, Filey, Bridlington and Hull. (Author's collection)

Ex-LNER Thompson B1 class 4–6–0 No. 61229 of Bradford shed (37C) hauling a single coach through Filey station towards Scarborough in the 1950s. Traffic in the early years on the line around Filey was mostly agricultural and there were few passenger trains. By 1910, the situation had improved and there were six through trains between Hull and Scarborough, most stopping at all stations and taking some two-and-a-half hours for the 53¾ miles. However, the 4.50 pm from Hull called only at Filey and reached Scarborough at 6.05 pm (a total time of 1 hour 15 minutes). A further train left Hull at 4.55 pm, called at Cottingham, Beverley, Driffield, Bridlington, Flamborough, Hunmanby, and Filey, arriving Scarborough in 1 hour 38 minutes. On Saturdays, the train called at Bempton and Speeton if requested to do so. There was then a non-stop train from Hull to Bridlington at 5.30 pm, covering the 30¾ miles in 40 minutes. On Sundays there was a 7.00 am train from Hull and a 5.00 pm from Scarborough, calling at all stations and taking 2 hours 25 minutes.

Growth of holiday traffic in the 1930s summer Saturdays saw many additional trains. The summer of 1938 saw a 10.30 am departure from Scarborough Central station every weekday for Kings Cross which collected passengers at Filey, Bridlington (if going via Doncaster) and Driffield. During the 'Wakes Weeks', several trains ran via Filey to Scarborough Central and Londesborough Road and journeys could become unpleasant as non–corridor vehicles would often be used. Many of these trains would take the Selby line at Driffield to avoid Hull. (H. Metcalf)

A winter view of Filey station in the 1950s giving a good view of the overall roof as well as the signal box on the left and the goods shed and yard on the right. (Harry Metcalfe Collection)

Ex-LNER B1 Class 4–6–0 No. 61256 of York shed (50A) at Filey station. Part of the station roof has been removed in this view. In 1965, BR planned to remove the train shed roof, due to maintenance costs, and replace it with cantilevered awnings over the platforms. The hipped section at the Scarborough end was removed but work had to stop because any further removal would have made the walls unsafe. Except for the removal of the ventilating section no further work was done until the early 1970s when the other hipped section was removed. In 1988, BR sought to have listed building status removed from Filey Station, having had listed status since 1985 as one of the very few remaining stations with a single span roof. Scarborough Council refused to, de-list the station and BR's appeal to the Secretary of State for the Environment also failed. BR stated that it would cost some £454,000 to put the roof into good condition in 1990 and appealed to railway preservation societies to help fund such work, but money would only be forthcoming if the whole roof was restored, after removal had been partially done over the previous twenty years. In 1987, inspection revealed that the roof was in poor condition, sections of roof trusses were severely corroded and purlins in danger of collapse. Grants offered to restore the roof in 1990:

Railway Heritage Trust:	£100,000
English Heritage:	£73,600
Filey Town Council:	£15,000
Scarborough Borough Council:	£10,000
BR:	£160,000

This left a shortfall of £95,400 [*continued opposite below*]

An unidentified ex-LNER B1 4–6–0 is seen passing through Hunmanby station in the late 1950s. When BR announced that it wished to close the line between Seamer and Hull in 1968 there was uproar and some 3444 objections were lodged. On 29 July 1969 the then Minister of Transport refused consent to full closure. Agreement was reached to close stations at Lowthorpe, Burton Agnes, Carnaby, Flamborough, and Speeton. The grant to keep the line operating would be paid by the government. (H. Metcalfe)

The BR Community Fund would match Local Authority funding, which would provide another £25,000 and BR agreed to find another £20,000 if Scarborough Borough would contribute another £10,000 and Filey Town Council a further £5,000. Therefore, the BR Community Fund would contribute another £15,000 as part of their commitment to match Local Authority funding. This still left a shortfall of £20,000, but this was manageable within repair budgets. Fabrication and erection of hip ends were completed by the end of 1990/1 and some work would carry over until 1991/2 creating the possibility of obtaining new grants to cover the restoration work. The complete restoration was done by 1993 and the roof was actually brought back to the original design of George Andrews. (H. Metcalfe)

Hunmanby station looking towards Filey in NER days. The main station house has now become a private home and the track from here to Bridlington has been singled, giving the line a rural branch feel. The section between Filey and Hunmanby remains doubled, but it is a single line from Seamer to Filey. (LOSA)

After leaving Hunmanby, the line passes through the site of Speeton station before arriving at Bempton station, seen here in NER days. The station here is still in use, served by trains between Seamer and Hull. (LOSA)

A timetable for trains operating between Scarborough and Hull in 1922, only months before the NER would cease to exist, becoming a constituent of the LNER at the 1923 'Grouping'. (Author's collection)

Overleaf: When winters were winters, ex-LNER D49/1 4-4-0 No. 62710 *Lincolnshire* of Bridlington shed (53D) waits to leave Flamborough station on a cold and snowy winter's day in the early 1950s. Even the poor crossing keeper looks cold. The station was some distance away from the village and for many years, Bradshaws warned passengers alighting at Flamborough station that a walk of two-and-a-half miles was required to reach the village, with a further three-and-a-half miles to the North Landing and lighthouse also awaited them. The railway here also allowed the establishment of the 'Flamborough and Filey Bay Fishing Company' who set up a wet fish stall on Victoria Bridge Street, Salford, close to Manchester Victoria railway station. Fish caught in Filey Bay were sent by rail to the stall here, which was supported by the Lancashire and Yorkshire Railway (Who owned Victoria station), for sale to the local Manchester population. Fishermen from Flamborough came to Salford to oversee sales in the market and they stayed at the 'Old Ship' and 'Fishermens Hut'. The venture was short lived. The 'Fishermens Hut' was demolished in 1894 and the 'Old Ship' was destroyed during the Manchester blitz of 1940. Flamborough station closed in 1970, while Bempton and Hunmanby stations remained open. Housing development in Bempton and Hunmanby suggests that it was the right thing to retain those stations. From Flamborough, the line goes on to Bridlington before running through to Hull. (Harry Metcalfe Collection)

133

FIVE

THE FILEY CAMP BRANCH

Destined for a short life of around 30 years, the little branch to Filey Camp station was opened, with due ceremony, in May 1947 to serve Butlin's Holiday Camp. This new camp had been opened two years earlier, on 2 June 1945, but had originally been planned to come on May 1940, had the Second World War not intervened, plans for the camp having been approved by the Local Authority in May 1939.

Advent of the 'Holidays with Pay Act', 1938 was the inspiration for Billy Butlin to establish 'Holiday Camps' along the British coastline, advertising them with the slogan: 'a week's holiday for a week's pay'. His first holiday camp was at Skegness, opened in 1936, followed by another at Clacton two years later. While the camp at Clacton was being built, Billy Butlin was looking for another site, which would retain a link with the LNER, who had been persuaded to pay half of the advertising costs for the Skegness camp, and who also had a rail connection to the Clacton camp. The site chosen lay some two miles south of Filey and close to the village of Hunmanby. This new camp was planned to be a showpiece and was designed to accommodate 10,950 campers. Construction had begun when war was declared which forced work to stop. However, the War Ministry persuaded Butlin to finish his camp and it became RAF Hunmanby Moor on completion in 1941, housing some 6000 personnel. At the end of hostilities, half of the camp was returned to Butlin's and was found to be in good condition. With assistance of 400 RAF staff, Filey was opened as a holiday camp in June 1945, initially taking 1,500 campers, numbers quickly rising to 5,000.

A condition for planning approval of the camp at Filey was that a direct rail connection from the main Seamer–Hull line had to be built. The LNER applied for an order permitting construction, which was granted in July 1945. The new branch left the main line at Royal Oak Junction (Royal Oak South for the south curve and Royal Oak North for the north curve) and ran for 64 chains to Filey Holiday Camp station which had two island platforms 900 feet long. The junction from the main line formed a triangle and engines were turned there. Estimated cost of the branch and station was £98,000. The new station was officially opened by Lord Middleton, Lord Lieutenant of the East Riding of Yorkshire, at 10.30 am on Saturday 10 May 1947, the first train to leave after the official opening was a service to York hauled

by B1 4–6–0 no. 1018 *Gnu*. However, trains had been operating since the previous Saturday, 3 May, and there had even been the occasional train along the branch in 1946. Trains to the camp usually ran on Saturdays only during the summer months and such services came from places such as Leeds, Manchester. Newcastle, Birmingham, and London. During the week a number of local services ran between Scarborough and Bridlington and called at Filey Camp station, often bringing day visitors to Butlin's camp.

The little branch to Filey camp was well used during the summer season, with the majority of campers coming by rail in the 1950s, although this was to tail off as road competition grew and, by 1975, numbers had fallen to less than one in ten, which would lead to the final demise of branch and station.

The entrance to the Filey Camp branch, which served Butlins Holiday Camp here. The North Junction is on the left and South Junction is on the right. In the background, Filey Brigg is just visible. (H. Metcalfe)

An unidentified ex-LNER B1 4–6–0 heads a short passenger train on to the branch from North Junction in the early 1960s. (H. Metcalfe)

Passing the modern signal box controlling the junction for Filey Camp branch, with the entrance to South Junction trailing off to the lower right of the picture, ex-LNER B16 4–6–0 No. 61446 of Leeds (Neville Hill) shed (50B) heads an express for Scarborough. (H. Metcalfe)

An unusual visitor to the branch was this ex-LNER A3 pacific No. 60084 *Trigo* busy shunting its coaches during the 1960s. (H. Metcalfe)

Plans of Filey Camp branch around 1950. The entrance to the branch formed a triangle with the main Seamer–Bridlington line, which would prove useful for turning preserved steam locos in the early years of steam excursions to Scarborough before the branch was closed. (Author's collection)

139

A photograph depicting the celebrations associated with opening of the Filey Camp Branch on 10 May 1947. The local *Filey Gazette* of 17 May, reported the event thus:

Last Saturday Butlins Filey Camp was en fete when some thousand guests were invited to the Ceremonial Opening of the 'Filey Camp' Station.

Butlins Filey Luxury Holiday Camp is now the happy possessor of its very own station, for the new L.N.E.R. line and station have been built specially to serve Butlins Filey Camp. The name of the station is 'Filey Holiday Camp.' The new railway, which is double throughout, forms a Y junction with the L.N.E.R. Hull–Scarborough line, about half–way between the Filey and Hunmanby stations. From the point where the two arms of the Y unite, the line runs into the new station which is provided with four platform lines and sidings, engine pits and water columns.

At the end of the two island platforms, each measuring 900ft. long, is circulating area, and here temporary station buildings have been erected. These will be replaced by permanent offices, etc. as materials become available (this was still the austerity period after World War Two and building material was in very short supply). Direct access to the camp, which is at present across the highway, eventually will be by means of a roadway and subway under the main Filey–Bridlington road. The length of the new branch railway, including both arms of the Y which connect it with the existing Hull–Scarborough line, is a little over a mile, and in the excavation and forming into embankments, about 100,000 cubic yards of material have been involved. Three new signal boxes have been provided, one is at the Camp station and one at each point of junction with the Hull–Scarboro' line. The ceremony of the Opening and Naming of the Filey Holiday Camp Station was performed in brilliant weather by the Rt. Hon. Lord Middleton, M.C. (Lord Lieutenant, East Riding of Yorkshire), supported by Mr. Geoffrey H. Kitson, Director L.N.E.R.; Sir Charles Newton, Chief General Manager, L.N.E.R.; Mr. Ian Anderson, O.B.E., M.C., Chairman Butlins Ltd.; and Mr. W.E. Butlin, Managing Director, Butlins Ltd.; before what we should say must surely be the most representative gathering ever assembled in Filey comprising as it did Mayors and Mayoresses from all over the East Riding, and even further afield. Filey Councillors with their Clerk and other officials.

Every newspaper of note was represented, a special train from London having brought those connected with the great London dailies and weeklies, and all the Sunday papers carried pictures and accounts of this unique occasion, and so Filey got another of those enormous advertisements which Butlins Camp is so frequently bringing about.

At 11 a.m., the first train to depart steamed out laden with campers and the crowd on the platform gave them a parting cheer. Mr. Butlin never does things by halves and after he and his wife had received and shaken hands with everyone of them, luncheon was served. A special programme of events was provided in the camp for their delectation during the afternoon, and at 6-30 dinner was served. In the evening there was a grand orchestral concert in the Viennese Theatre by the London International Orchestra under the baton of Fistoulari, and their programme consisted of Overture, The Barber of Seville, Rossini, Piano Concerto No. 3 in C minor Beethoven, Solo Pianoforte, Solomon, and Symphony No.5 in E minor, Tchaikowaky (sic). Here surely is something to marvel at the London International Orchestra in Filey, without Butlins Camp Filey could never have hoped to reach such heights.

An impressive event indeed, especially during these grey post-War austerity days. However, the entertainment provided for this event would not be a reflection of what the usual campers would have expected as they spent their 'Week's holiday for a week's pay', something more 'earthy' would have been required. (Butlins Archives)

The only accident to occur on the branch was on 25 August 1956 when ex-LNER K3 2-6-0 No. 61846 hit the buffer stops when hauling a train of 10 coaches to the camp. Damage to the engine can be seen here. Events leading up to the incident began at Bridlington in the early hours of that morning. The coaches had been stationed in Bridlington overnight and the engine arrived from Hull that morning. The driver took over the engine at 6.40 am and left Hull shed 10 minutes later, reaching the carriage sidings at Bridlington at 7.00 am. The driver reversed his engine onto the coaches, which moved away on contact. The guard put on the handbrake in the leading van and the fireman coupled the engine to the coaches, placed the link on the hook but did not tighten the couplings or connect the vacuum hose from the tender to the leading coach. The vacuum was destroyed in the engine to allow the train to be coupled up. The driver asked the fireman if everything was alright and on receiving assurance that it was, he recreated the vacuum and placed the handle in the running position. The guard arrived 15 minutes before the train was due to leave, left his equipment in the rear brake van and walked to the front to await the engine. After the train had been coupled, he took the brake off the front van and shouted for the driver to start. The train moved off at 7.04 am, four minutes late, direct from the sidings to the main line. The train worked well and between Hunmanby and Royal Oak the signal was set to caution and the driver applied the brakes but speed was not reduced from between 40 and 50 mph. At this point, the fireman realised he had not connected the vacuum brake pipe and told the driver. The driver told the fireman to apply the handbrake and gave a 'pop' whistle to indicate that the train was out of control, the driver tried to put the engine in reverse gear. The signalman in Filey Camp box accepted the train from [*continued opposite*]

An aerial view of Butlins camp at Filey in the mid 1970s. The railway station can be seen in the top left hand corner of the picture and looks deserted, while the car park appears quite full. Changes in transport habits, and the growth of private car ownership spelt doom for the station and it closed in 1977. Although it was mainly used on Saturdays, some local trains called during the week, bringing in day visitors to appreciate the facilities on offer. (Crimlisk-Fisher Archive, Filey)

the signalman in Royal Oak South box, who, on seeing the train going too fast, sent 'Train Running Away on Right Line' to the Camp box, who then set the road to give the train a straight run into the unoccupied No. 3 platform and station staff moved passengers away to safety. The train lurched around the south curve and the porter, who realised that the train was out of control, went to the front brake van and applied the hand brake. This application of the brakes reduced speed down to 35-40 mph, and the train hit the buffers at around 25 mph. The fireman then went to inform the guard that he had not connected the vacuum hose. The train was of empty stock, and the fact that station staff had moved passengers on the platform to safety, meant that there were no casualties. (H. Metcalfe)

Another aerial view of Filey Camp, with the railway in the background. (Crimlisk-Fisher Archive, Filey)

YOUR GUIDE TO A PERFECT BUTLIN HOLIDAY AT FILEY

1. SUBWAY TO RAILWAY STATION
2. WINDSOR DINING HALL
3. REGENCY BUILDING
 Theatre Bar, Discotheque
4. GROSVENOR RESTAURANT AND YORK DINING HALL
5. EMPIRE BUILDING
 Includes Empire Theatre, Ladies' and Gents' Hairdressing Salons, Newsagents and Turf Accountants.
6. OASIS COCKTAIL BAR
7. INDOOR HEATED POOL
8. AMUSEMENTS ARCADE POOL
9. OUTDOOR POOL
10. BRITISH RAIL OFFICE
11. CHILDREN'S THEATRE
 including Parents' Lounge, General Post Office, Photographic Shop and Shoe Shops.
12. FRENCH BAR
13. VIENNESE BUILDING
 Includes Viennese Ballroom and Viennese Coffee Bar.
14. KENT DINING HALLS
15. ROLLER SKATING RINK
16. RECEPTION
17. GARAGE AND PETROL PUMPS
18. FREE AMUSEMENTS PARK
19. AMUSEMENTS ARCADE
20. BEACHCOMBER BUILDING
 Includes Licensed Lounge, Coffee Bar, Old Time Ballroom, Games Room, Lounge, Whist and Chinese Restaurant.
21. SHOPPING CENTRE
 Includes R.C. Chapel and Campers' Mail Office.
22. LAUNDERETTE, SUNDAE BAR AND IRONING ROOM
23. RESTAURANT AND GOLDEN GRILL
24. HOLIDAY FAYRE RESTAURANT
 C. of E. Chapel and Bingo.
25. THE FRY including FISH RESTAURANT
26. ROPE RAILWAY STATION
27. TENNIS COURTS
28. CHILDREN'S PADDLING POOL AND PLAYGROUND
29. GAIETY BUILDING
 Includes T.V. Rooms (B.B.C. and I.T.V.), Gaiety Theatre, Quiet Lounge, Amusements Arcade, Table Tennis and Darts, Lost Property Office.
30. PUTTING GREEN
32. STADIUM BUILDING
 Includes Coffee Bar, Sports Stadium, Bingo, Billiards Hall.
33. CHILDREN'S NURSERY AND INFANTS' CENTRE
34. FIRST AID POST
35. BOATING LAKE AND MINIATURE RAILWAY

A plan of Filey Camp in 1970, showing how the camp was laid out and where all the facilities were. (Butlins Archives)

The indoor swimming pool at Filey Camp in the 1950s, showing how busy the camp could be. There is a story that Barclay's Bank in Filey would remain open on Saturdays during the summer to take cash paid by holidaymakers as they entered the camp. Cashiers used to take the money on admission and put it in bins. These bins would then be put in the back of a Morris Minor van for transit to the bank. Often, this van would be halted at Royal Oak level crossing due to the number of train movements. Had anybody realised this, and what the van was carrying, an attempt would have been made to rob it. This, however, was the 1950s and people tended not to think like that. (Butlins Archives)

The tennis courts and children's playground at Filey Camp in the 1950s. In the summer of 1953, the camp was being advertised for its gardens and the *Filey News* claimed that it was 'Yorkshire's new Beauty Spot' with 'Hundreds of acres of gardens and shrubberies'. Day admission at this time was 2s 6d (12½p) for adults and 1s (5p) for children. (Butlins Archives)

The famous chalets at Butlins Filey Camp, which were quite simple buildings and were set in attractive gardens here. Filey Camp saw its last summer season in September 1983, as the company announced the immediate closure of the camp on 18 October that year. At the time, the camp employed some 101 permanent and 1,100 seasonal staff and closure came as a shock. As the camp provided 2% of Scarborough Council's income, they were keen to find a new buyer, and a developer bought the camp for £7 million, the plan being to build luxury holiday bungalows on the site. Plans did not materialise and creditors foreclosed. The site was later bought by Birmingham Estates in 1988, who had plans to totally redevelop the site, but Scarborough refused planning permission and the site remained until taken over by Hull-based developer Essential Vivendi Ltd in 2007 who are consrtucting a holiday development of houses to be known as 'The Bay, Filey' which will extend all over the Butlins site (Butlins Archives).

Advertisements for Butlins Holiday Camps in the 1960s. (Butlins Archives)

Left: The Butlins Filey Entertainment Programme, showing what was on at the camp during the summer. (Butlin Archives)

Below: The fromt of a programme for an Annual Dancing Festival at Filey Camp. The festival lasted for a week from Saturday 8 September to Saturday 15 September 1951. Both amateur and professional dancers could enter this Old-Time and Ballroom dancing competition. The event brought competitors from all over the U.K. and abroad. This extended the 'season' for a while and, at that time, the competitors were very likely to have come to Filey Camp by rail. (Butlins Archives)

SIX

RENAISSANCE

The demise of steam traction on British Railways in the 1960s should have 'brought the curtain down' on this form of motive power as modern diesels heralded a more modern and cleaner railway to the area around Scarborough. However, almost as soon as the steam locomotive had disappeared from the network, efforts were being made to bring it back.

Over at Pickering, B.R. had argued that the line to Whitby, via Grosmont, was losing around £50,000 a year, a figure disputed locally, and despite attempts by local authorities to keep lines through Pickering open, they had all closed on 8 March 1965. Only two years later, the 'North York Moors Railway Preservation Society' had been formed with the intention of reopening the line from Grosmont to Pickering (the line from Middlesbrough to Whitby, via Grosmont being retained by BR). In 1968, the society needed to find £100,000 to purchase the line, a sum well beyond its means, so a five-and-a-half mile section was bought after protracted negotiations, between Grosmont and Ellerbeck for £35,000. Concern that a new railway terminus at Ellerbeck was in the middle of the National Park, and a railway would offer better access to the beauty spot at Newton Dale, rather than the narrow lanes in the area, brought interest in the proposed preserved railway from North Yorkshire County Council, the authority purchasing the remainder of the line to Pickering, a lease-back arrangement being agreed with the railway preservation society.

Public services began on the North Yorkshire Moors Railway on 22 April 1973, steam haulage being restricted to the Grosmont–Goathland section. Official opening took place on 1 May by the Duchess of Kent. For the first two years of operation, trains terminated at a temporary platform at Pickering High Mill, Pickering station itself was planned for demolition, despite being a listed building, to make way for a supermarket and car park. When these plans were dismissed, volunteers began restoring the station and trains began to use it from 24 May 1975. By 1976, steam traction was used for services along the whole of the line.

Meanwhile, steam locomotives began to appear on the main line around Scarborough. The first of these steam excursions began on 16 June 1973, when two ex-LNER streamlined A4 Pacifics, no. 60019 *Bittern* and no. 4498 *Sir Nigel Gresley* brought in a train from York. On arrival at Scarborough, the locos ran light engines through Filey to the triangle at Filey Camp to be turned, as the turntable

at Scarborough had been removed and the pit filled in. Since this first excursion, there have been several summer steam hauled trains running between York and Scarborough, many reviving 'The Scarborough Flyer' headboard on the loco ... Steam locos used on these trips have included ex-LNER A3 Pacific no. 4472 *Flying Scotsman*, Thompson B1 4-6-0 no. 61264, ex-LMS Black Five 4-6-0s no's 5000, 5305, and 45407, ex-BR 9F 2-10-0 no. 92220 *Evening Star* (the last steam loco built by BR), ex-LMS Duchess Pacific no. 46229 *Duchess of Hamilton* and, of course, record breaking A4 Pacific no. 4468 *Mallard*. In the last couple of years ex-GWR 4-4-0 no. 3440 *City of Truro*, ex-LNER V2 2-6-2 no. 4771 *Green Arrow* and ex-SR King Arthur Class 4-6-0 no. 30777 *Sir Lamiel* have worked between York and Scarborough.

Filey Camp branch closed in 1977 and its tracks were lifted, which meant that there were no longer any turning facilities. Problems of turning steam engines at Scarborough were only solved when the turntable pit was dug out and the turntable reinstated in 1981. It is currently in use to turn steam engines on excursions from York.

Filey itself has had some steam excursions passing through between Scarborough and Hull, although not as frequently as those between York and Scarborough. Indeed, ex LMS Black Five no. 45407 headed a train through Filey station as recently as February 2005.

The railways around Scarborough are still able to offer a reminder of the glory days of the steam railway thanks to main line excursions and the preserved North Yorkshire Moors Railway's collection of steam motive power which has representatives from the old GWR, LMS, SR, BR, and, of course, the LNER. The NYMR also runs an occasional steam service from Pickering all the way through to Whitby, thereby recalling the days of NER and LNER trains between the two towns.

A map of the railways around Scarborough. (Author's collection)

Scarborough has seen preserved steam locos at the head of excursion trains from York during the summer months for many years. Here, in 2007, ex-LMS *Princess Royal* pacific No. 6201, the famous *Princess Elizabeth* is taking on coal after having brought in a train from York. She is carrying the headboard of the well-known 'Scarborough Flyer' which, in LNER days, was a fast express from York. (Author's collection)

New motive power arrives in Scarborough Station in the form of Diesel Multiple Units which operated over the local branches and on stopping trains to York, Filey, and Bridlington, thus ensuring the demise of tank engines. This appears to be an empty stock working out of the station to the shed. (R. Carpenter)

Another DMU train at Scarborough in the summer of 1965. Within three years, all steam motive power would disappear on the main lines and a steam ban was to be applied, although it did not last very long. (R. Carpenter)

Ex-LNER A3 pacific, the famous *Flying Scotsman*, on the triangle at Filey Camp branch with the 'Scarborough Flyer' from York when owned by Alan Pegler. This was the first steam loco to be bought for preservation, on the condition that it could run on the main line, despite the steam ban. It had two tenders because the old water troughs had been removed by then. The loco famously went on tour to the USA but was stranded there for a while, to be brought back home by Sir William McAlpine in 1972, after Mr. Pegler had found himself in financial difficulties. The engine is now part of the National Collection and has recently been restored. (H. Metcalfe)

Also entering the triangle at Filey is ex-LNER A4 Pacific No. 19 *Bittern* to be turned before returning to Scarborough to form part of the first train steam operated between York and Scarborough since the steam ban over the line had been lifted in June 1973. (H. Metcalfe)

The same loco at the head of a steam excursion on the Seamer–Hull line in the 1970s. Scarborough Council actively encouraged steam hauled excursions to the town as it could see the tourist potential of these venturess. When A4 Pacific, the world famous record breaker No. 4468 *Mallard*, was restored, Scarborough Council made a financial contribution. The purpose of this restoration project was to celebrate the 50th anniversary of its 1938 speed record. After restoration, the loco operated 'The Scarborough Flyer' excursion from York to Scarborough in April 1987. The engine made several runs to Scarborough during her record breaking anniversary year of 1988, no doubt bringing the hoped for benefits of operating these excursions. (H. Metcalfe)

The other A4 pacific to make the first excursion to Scarborough in 1973 was No. 4498 *Sir Nigel Gresley*, seen here as BR No. 60007 at Grosmont on the North Yorkshire Moors Railway in 2007. The loco had not long been fully overhauled in the nearby Grosmont workshops and turned out in early 1950s express blue. She was expected to return to the main line in 2008. (B. Unsworth)

A busy scene at Grosmont station on the NYMR during the summer of 2005, with BR locos in view. On the left is BR Standard Class 4 2–6–0 No. 76079 waiting to take the train back to Pickering, while Peppercorn K1 2–6–0 No. 62005 *Lord of the Isles*, on the right, has just brought the train in from Pickering and will go off to Grosmont shed for coaling and watering. (Author's collection)

Another view of 62005 at Grosmont. (Author's collection)

BR Class 4 No. 76079 waits to depart from Grosmont with its train for Pickering in 2005. (Author's collection)

After servicing at Grosmont shed, No. 62005 is ready to depart for Pickering with the last train of the day, summer 2005. (Author's collection)

A year later, and ex-Great Western Railway Churchward 2–8–0T No. 5224 with a passenger train for Pickering. The NYMR has locos which represent all four of the Grouping companies as well as ex-BR Standard types. (B. Unsworth)

Another view of ex-GWR Churchward 2–8–0T No. 5224. (B. Unsworth)

Waiting at Grosmont in 2006 is ex-Southern Railway S6 4–6–0 No. 825 after coming off shed. In the background is the tunnel built by the Y&NMR, replacing the narrower one, invisible on the left, built for horse drawn trains when the line first opened and is still in use to give public access to the loco shed. It is, perhaps, fitting that this line has been fully restored, being the oldest railway route in North Yorkshire. (Author's collection)

Ex-BR Standard Class 4 2–6–4T No. 80135 has taken on water at Grosmont after bringing in a train from Pickering in 2006. To the right is ex-GWR 2–8–0T No. 5224 which will take the train back to Pickering. (Author's collection)

Ex-BR Class 4 2–6–4T No. 80135 waits outside the restored wooden waiting room at Grosmont station. (Author's collection)

165

Another view of 2–6–4T no, 80135 at Grosmont. (Author's collection)

Ex-GWR 2–8–0T No. 5224 waits to depart with its train for Pickering in the summer of 2006. (Author's collection)

BR 2–6–4T No. 80135 simmers quietly at Grosmont in 2006. (B. Unsworth)

Waiting to depart from Grosmont in the summer of 2006 is ex-DMS 'Black Five' No. 45212 with a train for Pickering. (B. Unsworth)

Ex-LMS 'Black Five' No. 45212 departs from Grosmont for Pickering. Ex-LMS 'Black Five' 4–6–0s became quite a common sight on the main lines around Scarborough in steam days at the head of excursions to the town and to Butlins camp at Filey, so it is correct that an example should be preserved on this line as a reminder of the days when hundreds of trains with 'foreign' locos brought holidaymakers into the area. (B. Unsworth)

Ex-GWR Collett 0–6–2T No. 6619 in BR black is about to depart with a train for Pickering in 2006. (B. Unsworth)

Leaving Grosmont station, the line crosses over the local road by level crossing controlled by Grosmont signal box. Here, BR Standard Class 4 2–6–0 No. 76079 stops local traffic at the level crossing as it leaves Grosmont station with its train for Pickering in the summer of 2005. (Author's collection)

Using the level crossing from the opposite direction is BR 2–6–4T No. 80135 after leaving Grosmont shed. (B. Unsworth)

Ex-SR S6 4–6–0 No. 825 occupies the level crossing at Grosmont as it leaves the station with a train for Pickering. (B. Unsworth)

The NYMR has its loco shed and workshops at Grosmont, where locos are restored and maintained. Indeed, ex-LNER A4 Pacific *Sir Nigel Gresley* was fully restored here and was out-shopped in 2007. Several examples of the railway's fleet of engines can be seen inside the shed from the viewing gallery supplied by the railway company to view the locos. (B. Unsworth)

Another view of locos inside the shed at Grosmont, local tank loco No. 29 is in the foreground. (Author's collection)

Ex-GWR 0–6–2T No. 6619 waits outside the shed in 2006. (B. Unsworth)

BR 2-6-4T No. 80135 waits outside Grosmont shed in 2006. (B. Unsworth)

Another of the NYMR's collection sits outside the shed in the company of a diesel shunter. The loco is ex-LMS Ivatt 2-6-2T, which was used on local branch traffic, some of it in the local area. (B. Unsworth)

Ex-LMS 'Black Five' 4–6–0 No. 45407 now named *The Lancashire Fusilier* sits outside Grosmont shed awaiting duty. (B. Unsworth)

The nameplate for *The Lancashire Fusilier* at Grosmont. (B. Unsworth)

A scene at the back of Grosmont shed, showing all the materials associated with maintenance of steam locos. Ex-SR S6 4-6-0 No. 825 passes with a train for Grosmont. (B. Unsworth)

Rear of Grosmont shed with ex-LMS 'Black Five' No. 45118 and ex-SR S6 4-6-0 No. 825, along with diesel-shunter No. 12139, in view. (B. Unsworth)

Ex-SR Bullied 'West Country' Pacific No. 34028 *Eddystone* awaits restoration at Grosmont. The loco is keeping company with Class 50 diesel–electric loco No. 50027 in south-eastern livery. (B. Unsworth)

An ex-USA Baldwin loco No. 2253 is at Grosmont awaiting repair. An unusual loco for a British preserved railway. (B. Unsworth)

An unidentified ex-industrial Hunslet 0–6–0 saddle tank awaits restoration at Grosmont. The collection here extends beyond main line steam engines to industrial locos and diesels, many of these diesels being collectors' items in themselves, having been withdrawn from the main line for some years. (B. Unsworth)

The cab for ex-LMS 'Black Five' 4–6–0 No. 45428 which is to be reunited with its loco when fully restored. (B. Unsworth)

Taking on coal at Grosmont coaling stage is BR 2–6–4T No. 80135. (B. Unsworth)

BR 2–6–4T No. 80135 passes Grosmont shed with a train for Pickering. (B. Unsworth)

Approaching Pickering station, and the end of the line, is ex-BR 2–6–4T No. 80135. In BR days, the town was a junction of local lines, all of which were closed in the 1950s and '60s. (Author's collection)

A crowd waits for a train at Goathland station. The station here is famous as the location for YTV series 'Heartbeat' and has also been used as Hogwarts station in the Harry Potter films. (M. Forrest)

Ex-BR 'Schools' Class 4–4–0 No. 30926 *Repton* approaches Pickering with a train from Grosmont in 2007. The engine was restored here and put back into traffic in that year. (B. Unsworth)

BR 2–6–4T No. 80135 rests at Pickering after bringing in a train from Grosmont. (Author's collection)

Ex-GWR 0–6–2T No. 6619 has just arrived at Pickering with its train from Grosmont in 2007. (B. Unsworth)

Over at Scarborough, ex-LMS Stanier 8F No. 48151 takes on coal after bringing in an excursion train from York. One of her sisters, No. 48773, was the last 8F to be withdrawn, when it left Bolton shed in August 1968. (B. Unsworth)

The front of ex-LNER V2 2–6–2 No. 4771 at Scarborough in 2006 showing its *Green Arrow* nameplate. (B. Unsworth)

Green Arrow at Scarborough, celebrating the 15th anniversary of running the 'Scarborough Spa Express' in preservation. (B. Unsworth)

Another view of *Green Arrow* on the 15th Anniversary 'Scarborough Spa' express at Scarborough Station itself. (B. Unsworth)

Ex-SR 'King Arthur' Class 4–6–0 No. 30777 *Sir Lamiel*, newly restored, at Scarborough Station with an excursion from York in 2007. (B. Unsworth)

Ex-LNER A4 Pacific No. 60009 *Union of South Africa* on the Scarborough Spa Express in 2007. These A4s have been associated with Scarborough ever since the first preserved steam excursions ran to the town from York. (B. Unsworth)

A rear view of 30777 *Sir Lamiel* at Scarborough in 2007. (B. Unsworth)

Ex-SR 'King Arthur' 4–6–0 *Sir Lamiel* leaving Scarborough Station on its way back to York in 2007. (B. Unsworth)

Ex-LMS Stanier 'Princess–Royal' Pacific No. 6201 *Princess Elizabeth* at Scarborough Station having brought in 'The Scarborough Flyer' excursion from York in the summer of 2007. (Author's collection)

Ex-LMS 'Duchess' Pacific No. 6233 *Duchess of Sutherland* waits at Scarborough Station with its train to York in the early 2000s. (B. Unsworth)

Ex-LMS 'Duchess' Pacific No. 6233 *Duchess of Sutherland* in LMS crimson lake livery leaves Scarborough Station with the return trip to York. (B. Unsworth)

RAILWAYS AROUND SCARBOROUGH

Railway	Opened	Closed	Comments
Whitby–Grosmont	8 June 1835	–	Line continues to Middlesborough following opening of line along Eskdale to Castleton on 2 October 1865
Grosmont–Pickering	26 May 1836	8 March 1965	Now is the North Yorkshire Moors Preserved Railway
Pickering–Malton	7 July 1845	8 March 1965	
Scarborough–York	7 July 1845	–	
Seamer–Filey	5 October 1846	–	
Filey–Bridlington	20 October 1847	–	
Gilling–Pickering	1 April 1875	2 February 1953	Line opened in stages
Pickering–Seamer	1 May 1882	5 June 1950	
Whitby–Loftus	3 December 1883	5 May 1958	Whitby West Cliff station remained open until 12 June 1961 and the line from there to Whitby Town until 8 March 1965
Scarborough–Whitby	16 July 1885	8 March 1965	
Filey Camp Branch	10 May 1947	17 September 1977	

ACKNOWLEDGEMENTS

Without the support of many people this book would have been very difficult to complete. Therefore, I should like to thank organisations and individuals without whose help I could not have completed the project. These people are as follows:

Eric and Sue Pinder of the Crimlisk-Fisher Archive, Filey, they were particularly patient when dealing with my many enquiries.

Filey and Scarborough libraries, Filey Town Council, and Roger Dowson of the Beck Isle Museum, Pickering.

I should also like to thank Roger Billington at Butlin's Archive, Bourne Leisure who was very prompt and supportive as the project was underway, supplying much material on the holiday camp in Filey.

Individuals who supplied pictures and information were:

Roger Carpenter, Bernard Unsworth, Harry Metcalfe, Jenny, Gordon and Steve of Filey, Louise Ferguson of Kirkbymoorside, Sue at Thornton-le-Dale, and George Anning. Some material also came from Marian Forrest of Llandudno and Lens of Sutton Association.

I should also like to thank my wife Hilary for her patience as I took over the house and anyone else connected with the project who I have failed to mention. I just hope that I have done justice to all of your contributions.

www.amberleybooks.com